Paintings *of* Portland

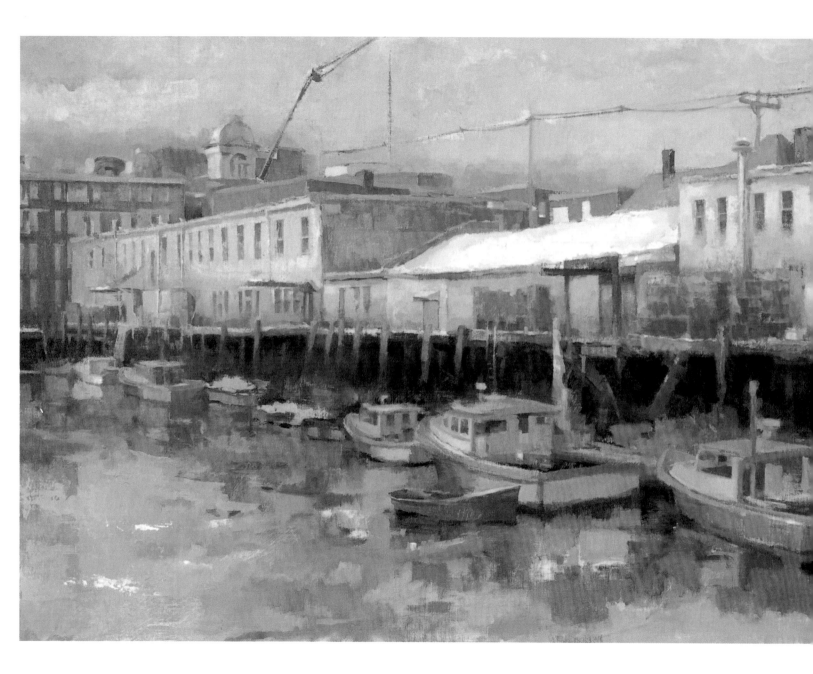

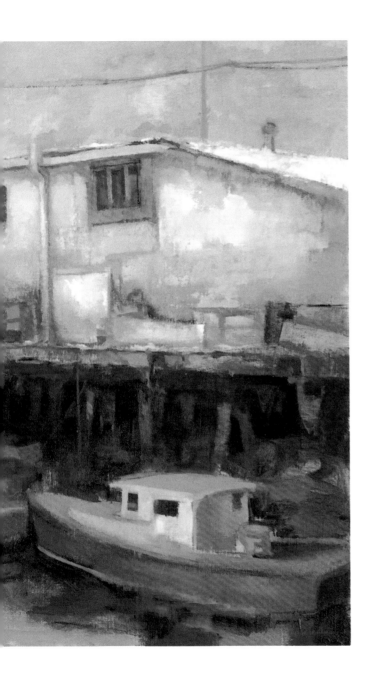

Paintings *of* Portland

CARL LITTLE and DAVID LITTLE

David Little

Down East Books

Down East Books

An imprint of The Rowman & Littlefield Publishing Group, Inc.
4501 Forbes Blvd., Ste. 200
Lanham, MD 20706
www.rowman.com

Distributed by NATIONAL BOOK NETWORK

Designed by Lynda Chilton, Chilton Creative

British Library Cataloguing-in-Publication Information available

Library of Congress Cataloging-in-Publication Data available

ISBN 978-1-60893-980-0 (hardcover)
ISBN 978-1-60893-981-7 (e-book)

 The paper used in this publication meets the minimum requirements of American National Standard for Information Sciences—Permanence of Paper for Printed Library Materials, ANSI/NISO Z39.48-1992.

Printed in the United States of America

Early Snow by Tina Ingraham shown on p. 2 and *Knights of the Harbor* by Jill Hoy shown on p. 6.

This book is dedicated to Peggy Greenhut Golden,
Earle G. Shettleworth Jr., William David Barry, and
Herbert Adams, all champions of Portland.

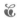

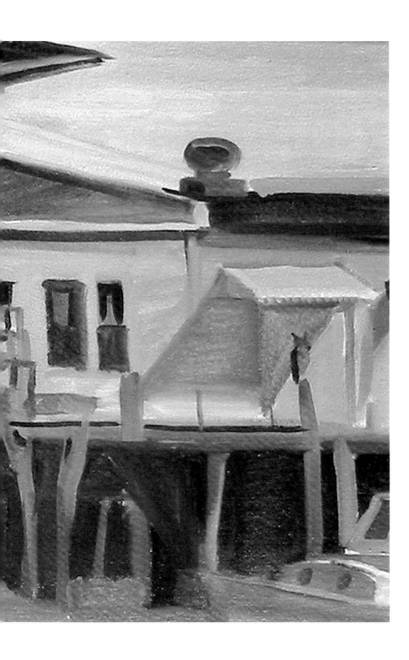

Contents

Acknowledgments

First and foremost, we are indebted to the artists who shared their work. As in past projects, we encountered a bounty of impressive work and had to make tough decisions.

We thank the following individuals and organizations for their invaluable help: Peggy Greenhut Golden, Jessica McCarthy, Greenhut Galleries; Maine State Historian Earle G. Shettleworth Jr.; William David Barry, Holly Hurd-Forsyth, Sofia Yalouris, Nicholas Noyes, Maine Historical Society; Erin Damon, Portland Museum of Art; Sandra Richardson, Barridoff Galleries; David Neikirk, Robert Spencer, Matthew Edney, Heather Magaw, Osher Map Library; Hannah Blunt, Mount Holyoke College Art Museum; Burbank Library; Maine State Museum; Brooklyn Museum of Art; Addison Gallery of American Art; Harvard Museums; Suzanne Bergeron, Bowdoin College Museum of Art; Bank of America and KeyBank; Jeffrey Tilou Antiques. We also tip the hat to Portland art dealers, past and present: Thomas Crotty, Annette and Rob Elowitch, June Fitzpatrick, Dennis and Marty Gleason, Edward T. Pollack, Chris Rector, Dean Valentgas, Andres Verzosa, et al. They have kept the Portland art fires burning. Today there are new galleries opening and many established and upcoming artists competing for space.

We are grateful to the many authors who have written so eloquently about Portland's artistic heritage, in particular historians Earle Shettleworth Jr., William David Barry, Jessica Skwire Routhier, Donna Cassidy, and Jessica Nicoll. We have also been blessed with fine critics, among them Edgar Allen Beem, Ken Greenleaf, Philip Isaacson, Dan Kany, and Bob Keyes.

We owe much of the photography in this book to Jay York, the go-to guy in Portland whose morning walk photographs over the years have chronicled a changing city. Ken Woisard, a fine-art photography wizard out of East Blue Hill, also provided many jpegs.

Renewed thanks to Michael Steere, Down East Books, for his enthusiasm and support; to Bill Bentley and Svet Kirtchev for key technical assistance; and to our families for their all-around support.

Finally, we give a special shout-out to the many organizations that are committed to preserving and enhancing Portland. A short list would include Greater Portland Landmarks, Portland Trails, and Creative Portland, as well as the many excellent "friends of" groups and neighborhood associations that work to preserve open spaces. Thanks to their stewardship, Portland remains, as Henry Wadsworth Longfellow deemed it, that "beautiful town that is seated by the sea."

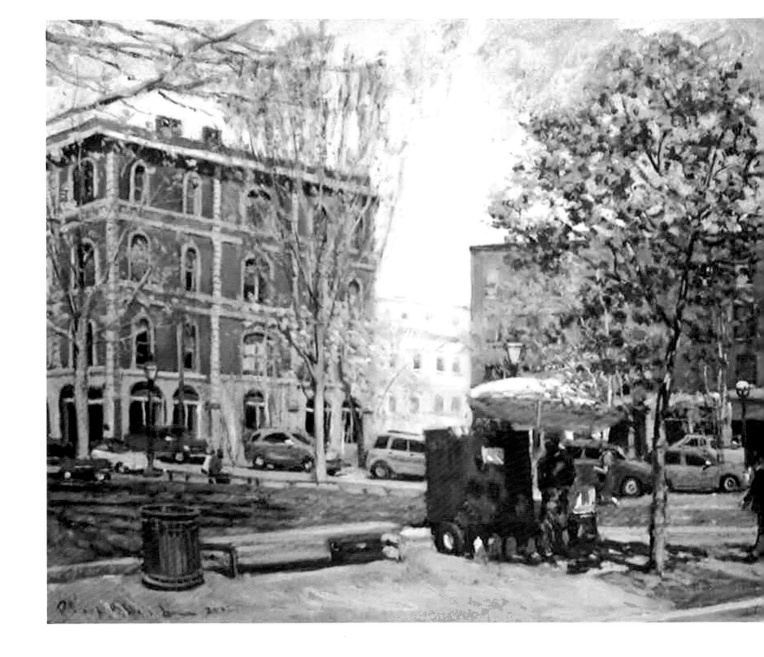

Introduction

"Portland, beautiful of situation, the joy of the whole earth, surrounded by the islands of Casco Bay, like gems in her crown, is a fitting city to form the front door of Maine."

—Louise Dickinson Rich, *The Coast of Maine, An Informal History and Guide*, 1956

P ortland has received all kinds of accolades in recent years, for its food, livability, diversity, and access to great natural beauty, among other characteristics. It's a happening place, vibrant and vital. The city that Herbert B. Jones referred to as "proud, placid, and prudent Portland" in his 1940 collection *Maine Memories* has got its mojo going in the 21st century.

As is fitting for a dynamic urban milieu, Portland is today a place of art and artists. The city, one of New England's most attractive, has developed a lively art scene, anchored by the Portland Museum of Art, the Maine College of Art, the University of Southern Maine, the University of New England Art Gallery, and other venues great and small. According to a 2017 report by Americans for the Arts, arts and cultural organizations had an economic impact on Portland of more than $75 million in 2015.

Today's open studios, street artists, and wet-paint fundraisers are set against a backdrop of business and community support, private collectors and patrons, and public institutions that are keepers of Portland's recorded history. While the gallery scene has had its ups and downs (see 2008), new spaces have opened in cafés, restaurants, and shops. The

Paul Black
Tommy's Park, Middle and Exchange
Oil on canvas, 2012
24 by 36 inches
Courtesy Paul Black Studio

annual summer sidewalk shows and Christmas craft fairs are popular, as is the First Friday art walk, a steady draw, year-round, for locals and out-of-towners alike—an across-the-city celebration of immense creativity and energy.

At the same time, over the past quarter century or so Portland has increasingly become a magnet for artists as a subject for their work, but also as a place for making and exhibiting art. Painters have taken up residence throughout the region, many of them responding to their surroundings, finding in the city their internal map, artistic values, and authentic voice.

Portland is, after all, a picturesque city, its visual enchantments easily accessible. From the Custom House Wharf to the Eastern Prom, from Deering Oaks Park to the Western Prom and Casco Bay Bridge, from Stroudwater to Fort Gorges, this "front door of Maine" provides the painter with a range of compelling motifs.

The parameters of what composes Portland have shifted over the centuries, its geographic span changing over time. Today, the city encompasses nearly seventy square miles. It borders Falmouth, Westbrook, and South Portland, and includes a clutch of islands in Casco Bay. For this book we chose to go with the "Greater Portland" designation, as it best suited our needs for visual and art-historical context.

The imagery in *Paintings of Portland* stretches as far south as Prout's Neck (so that we could include a classic Winslow Homer painting), west to Stroudwater and north to Maine Audubon's Gilsland Farm, and includes Peaks, Cushing, and Great Diamond Islands to the east. However, the main focus is the city itself, a marvelous assortment of streets, buildings, neighborhoods, parks, wharves, and walkways.

The wonderfully pictorial *A Map of Portland Maine and Some Places Thereabout* (1928), by Katherine Dudley, stretches the city even farther, to the Kennebunks and Sebago Lake. The hand-colored map, with its inventive border design and joyous blue-green palette, was created for the Portland Baby Hygiene and Child Welfare Association to suggest the health-giving environment of the Portland region. The wavy ribbon down the middle of Casco Bay features a quote from 17th-century British explorer Captain John Smith: "The country of Aucocisco at the bottom of a large deep bay full of many great isles."

Katherine Dudley
A Map of Portland Maine and Some Places Thereabout
Hand-colored map, 1928
75 by 99 inches
Courtesy Osher Map Library and Smith Center for Cartographic Education

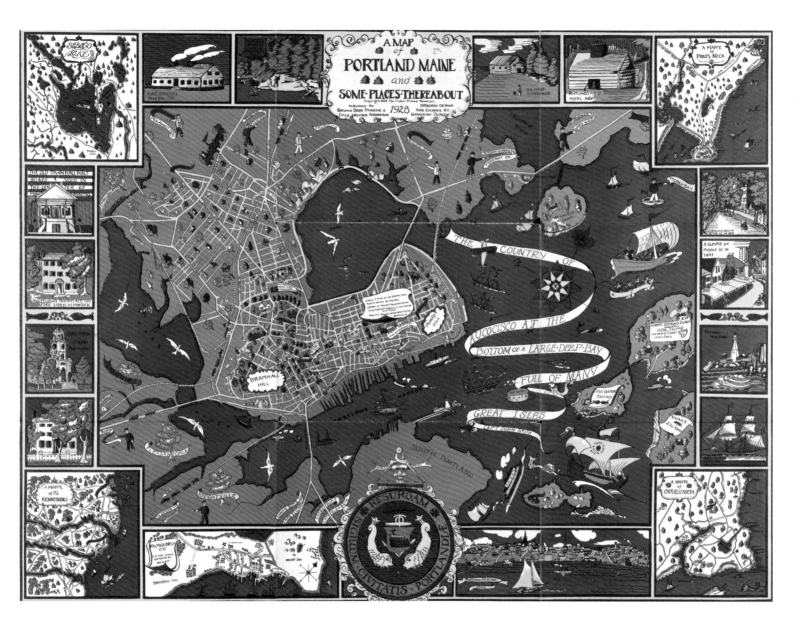

With the help of Earle G. Shettleworth Jr. and staff at the Maine Historical Society and Portland Museum of Art, we identified a selection of 19th- and early 20th-century images of Portland. The book does not have the broad scope of our previous collaborations (*Art of Katahdin*, 2013, and *Art of Acadia*, 2016), so we had to make strategic choices. Some of the paintings are well known; others we expect will surprise.

From the outset we knew we had a great source of contemporary imagery. In October 2002, Peggy Greenhut Golden, founder and director of Greenhut Galleries, launched the Portland Show as a way to celebrate twenty-five years of offering fine art from her space on Middle Street. This invitational, which would become a biennial event, featured fine art paintings, mixed-media works, prints, and objects inspired by the city that had nurtured her business.

Golden dedicated that first show to "all of the artists living and working in the State of Maine," without whose art, she stated, "our world would be bland and uninspired." The exhibition became an icon of the city's art scene; the ninth edition took place in April 2018.

The Portland Show has grown in importance as it has evolved, featuring a wide range of personal expression and styles, from Joel Babb's immaculate realism to Alice Spencer's marvelous zoning map abstractions. A number of artists in past shows had never painted in Portland. They took Golden's bidding as an occasion to explore the subject, gaining a new appreciation of the Forest City. That appreciation appears in the numerous personal anecdotes the artists shared with the authors in the course of producing this book.

As you look through this book, consider the changing visual dynamics of Maine's largest city, its growth and development, but also reflect on the ways in which Portland has been, and continues to be, a tried-and-true source of inspiration for artists of all aesthetic stripes. "Few towns in New England are equally beautiful and brilliant," Dr. Timothy Dwight, president of Yale University, said of Portland in 1807. Despite the vagaries of time and history, the city maintains its beauty and brilliance. Here are a few visuals to prove it.

Nathaniel Larrabee
Portland from Nissen Building
Oil on linen, 2006
36 by 40 inches
Private collection

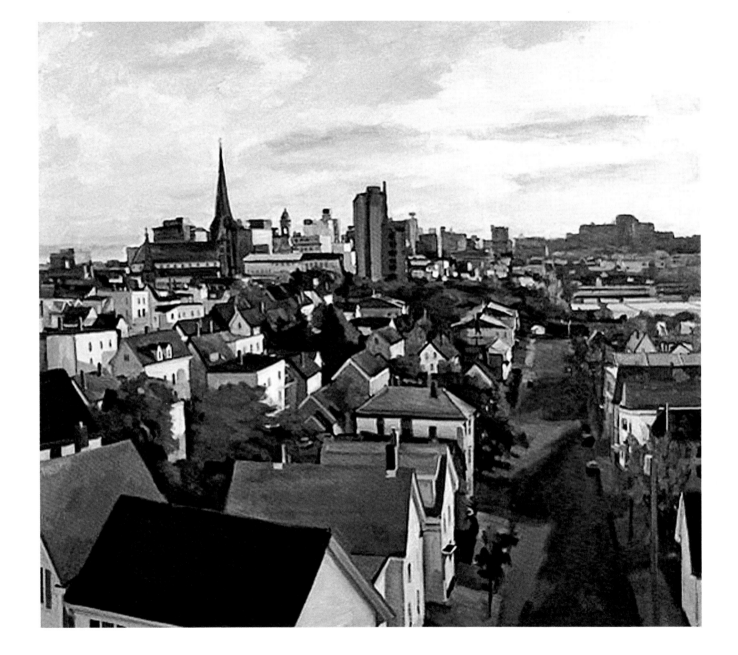

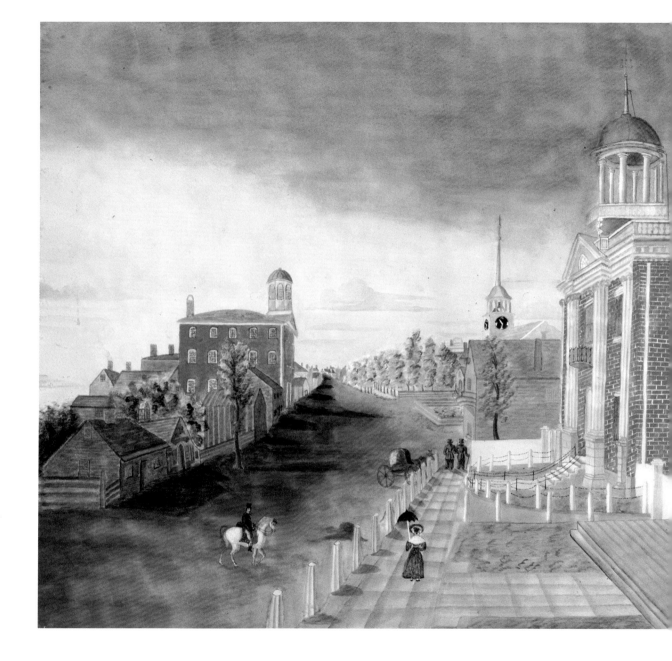

Anna M. Bucknam
Maine State House in 1820
Watercolor, ca. 1832
14¾ by 19½ inches
Collections of Maine Historical Society

Paintings *of* Portland:
THE PAST

"Perhaps no other type of visual art has defined Portland
as a place more than landscape painting."

—Donna Cassidy, "Framing Portland: From the Panoramic to the
Postmodern Landscape," *Creating Portland*, 2005

I n *Creating Portland: History and Place in Northern New England*, editor Joseph Con-
forti and his fellow essayists provide a rich and broad account of Henry Wadsworth
Longfellow's "beautiful town that is seated by the sea" from its earliest days as home
to the Wabanaki, who called it Machegonne, to its contemporary status as a bustling urban
center. The city's history has saga-worthy components, including devastating fires, mari-
time battles, brutal attacks, and urban renewal. Despite economic dips, resilient Portland
has nurtured and sustained a remarkable tradition of art and culture.

 In the early years, the city went through several name changes—Dartmouth, Casco,
Falmouth, etc.—before, in 1786, officially taking on the name we know it by today. From
1820 to 1832 Portland served as the capital of Maine. Anna M. Bucknam's watercolor
Maine State House in 1820, painted around 1832, shows a stately city with figures taking
the air on foot and horseback. The carefully rendered Maine State House presents a clas-
sical facade, joined by the august Cumberland County Court House next door, the brick

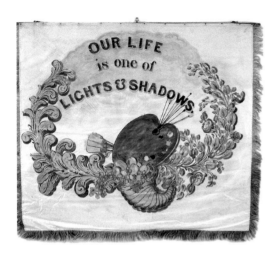

William Capen Jr.
(ca. 1801–1863)
Our Life Is One of Lights & Shadows
Oil on linen banner, 1841
Maine Charitable Mechanic Association Collections of Maine Historical Society

Portland Academy down the way, and the spire of the First Parish Church in the distance. Congress Street never looked so orderly.

Early on, the arts in Portland were promoted by the Maine Charitable Mechanic Association, a tradesmen's union of sorts that supported a variety of livelihoods, including painting. For a parade in October 1841, William Capen Jr. created a banner for the city's "Painters, Glaziers and Brush Makers" that mused, "Our Life Is One of Lights & Shadows."

Portland artists had a champion in John Neal (1793–1876), considered by many historians to be America's first art critic. Neal organized the earliest major show of local art in the city, at the Maine Charitable Mechanic Hall in 1838. "The landscape painters, born here or making their first appearance here," Neal wrote, "have given to Portland the highest reputation." He highlighted the exciting views offered by carriage rides along the coast to the north, "calm, tranquil and soothing" with "pictures at every turn," and the "rough sketches" and "rioting in foam and spray" found to the south.

Through various publications, including *Portland Illustrated*, Neal praised and promoted the work of a number of artists, among them Harrison Bird Brown. Writing in 1874, he recounted how he urged Brown, "with all earnestness, to try his hand at landscape, sea views, etc., to begin at once, and to lose no time." Brown received additional encouragement from his friend Edward Henry Elwell (1825–1890), editor of the *Portland Transcript*, who regularly reported on his activities. Elwell referred to Portland as "a center of pleasure travel" and included artists like Brown in his long list of "Distinguished Portlanders."

Brown (1831–1915) had a summer home and studio on Cushing Island and painted up and down the coast. He resided in his home city from his birth until 1893, when he moved to London. Popular and prolific, the artist's wide range of subjects, painted over a forty-year career, included many romantic coastal scenes of headlands and crashing waves.

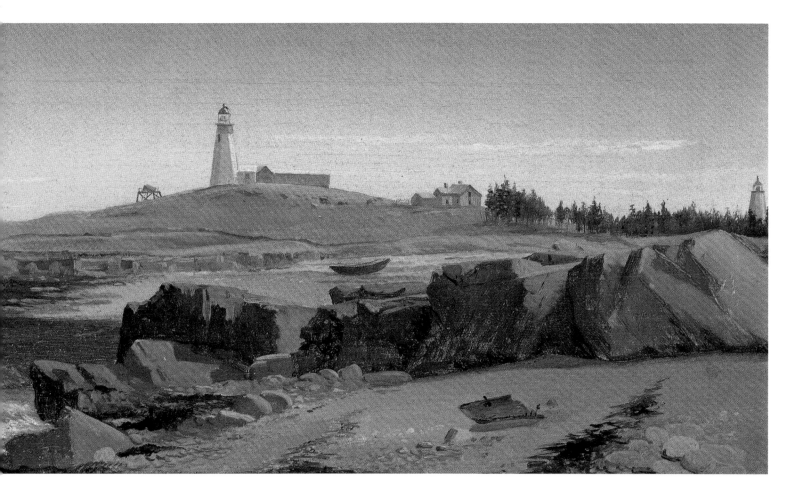

His paintings of Two Lights and the Venerable Cunner Association and Propeller Club on Long Point in Cape Elizabeth testify to this exceptional range and to sculptor Paul Akers's appraisal in a letter to the *Portland Transcript* in December 1860: "Indeed, shore and ocean in all their beauty and sublimity, in sunshine and in storm . . . all seem to be the true subjects of [Brown's] genius."

In addition to landscapes, Brown produced a number of "homestead" pictures, portraits of well-known houses, such as the "Forest Home" of the eminent Maine legislator

Harrison Bird Brown
Two Lights
Oil on canvas, no date
9 by 18 inches
Photo Jay York
Courtesy Barridoff
Galleries

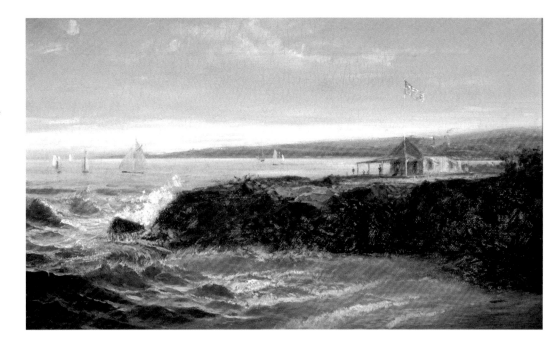

Harrison Bird Brown
*Venerable Cunner
Association and
Propeller Club*
Oil on canvas, no date
12 by 20 inches
Photo Jay York
Courtesy Barridoff
Galleries

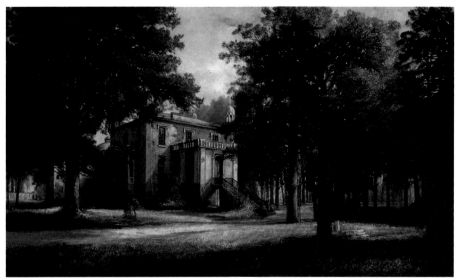

Harrison Bird Brown
*View of the F. O. J.
Smith House*
Oil on canvas,
1880–1881
18 by 30 inches
Portland Museum
of Art
On loan from the City
of Portland

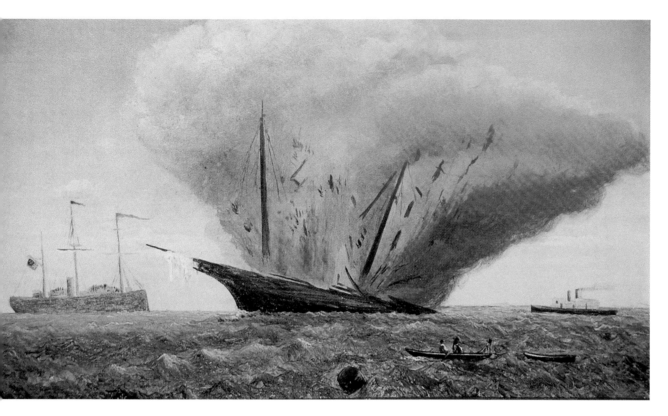

Levi A. Leonard (attributed)
The Destruction of the Revenue Cutter Caleb Cushing
Oil on canvas, 1863
8¼ by 15 inches
Photo Jay York
Courtesy Barridoff Galleries

F. O. J. Smith (1806–1876) in Baxter Woods. The painting, art historian Jessica Skwire Routhier has noted, "demonstrates . . . [Brown's] persistent interest in the dominance of nature over the edifices of humankind."

In a curious piece of history, Brown was part of a group of volunteers who pursued Confederates who stole the revenue cutter *Caleb Cushing* from Portland Harbor in 1863. A painting attributed to Levi A. Leonard shows the cutter exploding in flames after the Confederates set it afire; Union ships *Chesapeake* and *Forest City* can be seen at either side of the ill-fated ship. A witness, James Brackett, marveled at how the destruction unfolded, "the whole mass" of smoke and ship fragments "pausing a moment in mid-air before dropping with a crash into the water . . . and the *Caleb Cushing* is no more."

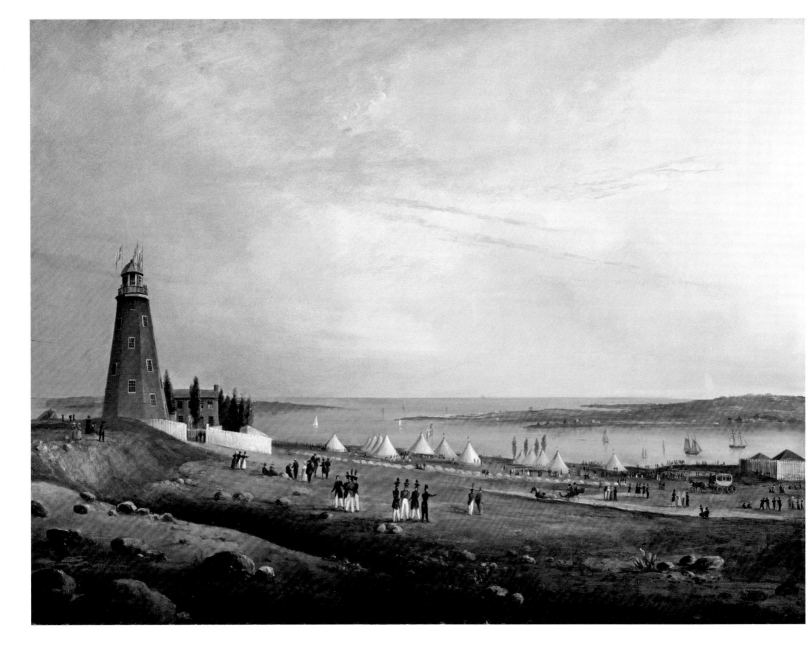

Neal also championed Charles Codman (circa 1800–1842), including thirty-six of his oil paintings in that 1838 show at the Mechanic Hall. Codman had painted signs, tea trays, clock faces, and other utilitarian items in and around Boston. In his early twenties, he began to advertise his services in the Portland area and eventually moved there as prospects improved.

As art historian Jessica Nicoll has observed, Codman initially made his name producing military standards, which were "at the elite end of the spectrum of ornamental painting." This special skill, Nicoll surmises, led to the painting *Entertainment of the Boston Rifle Rangers by the Portland Rifle Club in Portland Harbor, August 12, 1829*, a remarkable depiction of a military encampment on what was then called Mount Joy, today's Munjoy Hill.

Prominent in Codman's painting is the Portland Observatory, built in 1807 by ship captain and businessman Lemuel Moody (1767–1846) as a maritime signal tower. The observatory turns up again in a pair of small images on a hinged scallop shell painted circa 1908.

Charles Codman
Entertainment of the Boston Rifle Rangers by the Portland Rifle Club in Portland Harbor, August 12, 1829
Oil on panel, 1830
24½ by 32½ inches
Brooklyn Museum, Dick S. Ramsay Fund, 51.196

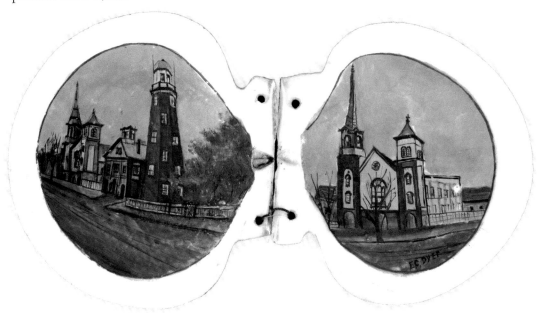

Unknown Artist
Eastern Promenade and *View on Mount Joy*, ca. 1908
Pair of painted scallop shells
Collections of Maine Historical Society

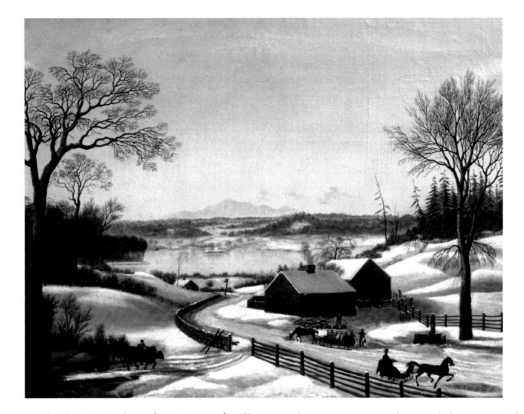

Charles E. Beckett (1814–1867) offers another moment in the city's history with *Winter Scene Near Portland*, circa 1848. The painting shows Dr. Summer Cummings leaving Portland on a mail delivery by horse and carriage. According to the aforementioned city chronicler Elwell, Beckett was the first native artist to attain distinction and was known for his "spirited drawing of horses." In addition to being a painter, he owned and operated one of two apothecaries in the city.

Longfellow may have seen Beckett's winter scene as he strolled around Charles Octavius Coles's Picture Gallery in Portland. Returning home in 1849 to be with his father, who was dying, the poet found solace in the showroom. "Sat on a sofa and the air of Art was wafted about me," he wrote in his journal on July 27, "and I had a delicious feeling of the old galleries come over me, as I looked dreamily upon the heads and landscapes."

The poet's niece Mary King Longfellow (1852–1945), Portland's most renowned nineteenth-century female painter, chose to depict picturesque elements of the city. In her watercolor view of the skyline in 1885, the handling of light and reflection is decidedly romantic, transforming the view of the city in the distance into a Venice-like vista. The avocation of art runs generationally in the family, with extensive holdings now in the Longfellow House-Washington's Headquarters National Historic Site in Cambridge, Massachusetts.

Mary King Longfellow
Portland Skyline
Watercolor, 1885
10¾ by 17 inches
Collections of Maine
Historical Society

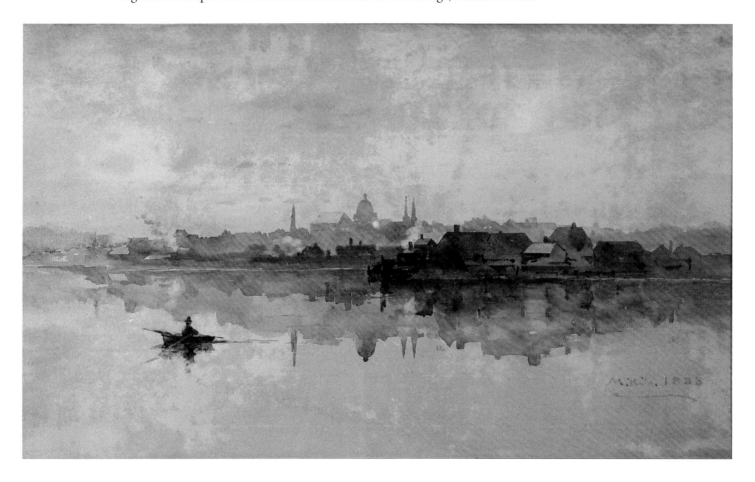

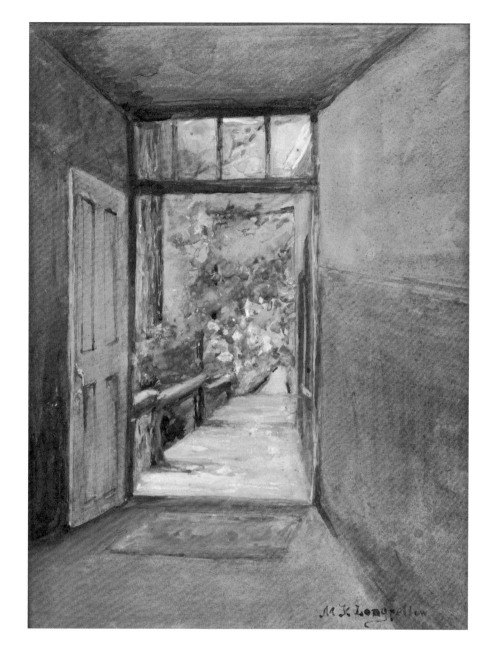

Mary King Longfellow
Door to the Garden
(Longfellow House,
Portland)
Oil on canvas, ca.
1900
13 by 10 inches
Collections of Maine
Historical Society

In another painting Longfellow depicted the flower garden as viewed through the back door of her uncle's house on Congress Street. Through the ongoing efforts of the Longfellow Garden Club to honor the early design sketches by landscape architect Myron Lamb, this Colonial Revival–style garden has become one of uptown Portland's notable visual attractions.

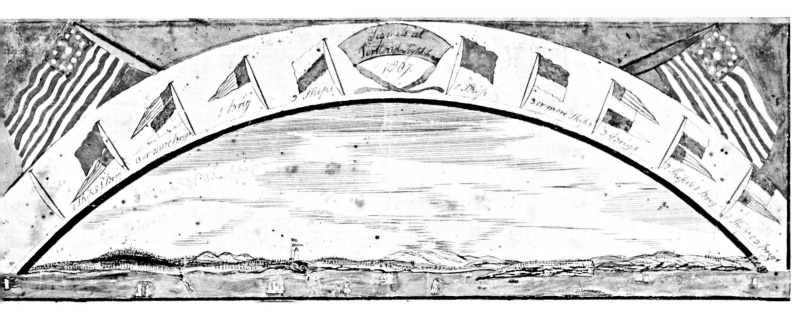

Portland's important role as a seaport and commercial hub—an "entrepot," as historian Conforti calls it—is underscored by many of the early images of the city. Lemuel Moody (1767–1846), a ship captain and businessman, created several signal guides in 1807. After sighting a vessel by telescope from the top of the Portland Observatory, a watchman would raise signal flags to let the ship's owners know their vessel was approaching the home port and prepare for its arrival.

Lemuel Moody
Signals at Portland Observatory (detail)
Watercolor on paper, 1807
15 by 12 inches
Collections of Maine Historical Society

When John William Hill (1812–1879) painted the city in the 1850s, he focused on the harbor, providing a detailed topographic view that featured boatbuilding activities. The painting, now lost, was made into a color lithograph and took the name *The Launching Print* on account of the ship-in-progress in the foreground. Published in several variations, the print was much sought after as a memento of Portland after the Great Fire of 1866.

A commissioned portrait of the clipper ship *Portland* in full sail painted in 1850 is testament to the skill of the city's boat builders, in this case, the Joseph Dyer shipyard in Ferry Village at Cape Elizabeth.

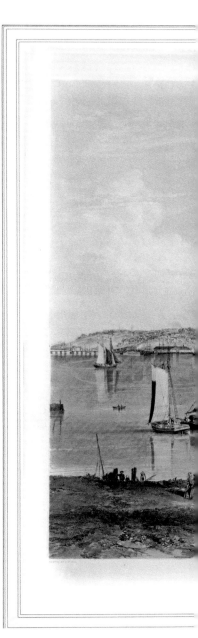

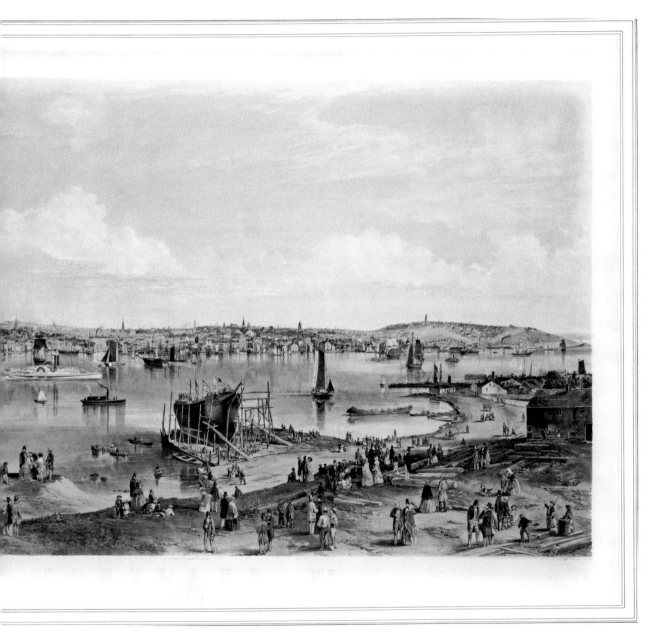

John William Hill
Portland, Maine (also
known as *The Launching Print*)
Color lithograph, 1855
25¾ by 39¾ inches
Charles Parsons Lithography, New York
Private collection

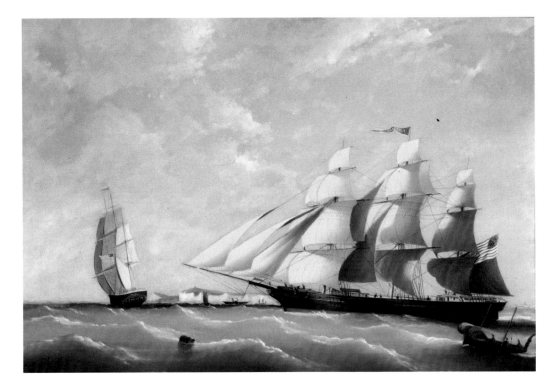

The public interest in popular painted landscape and maritime scenes, which arose in tandem with photography and printmaking, continued into the 20th century. I. Krouthen's *Russell Shipbuilding Company Yard* from 1919 features the structure of a large ship being built on the shore in the East Deering section of the city. The skeletal framework brings to mind some lines from Longfellow's "The Building of the Ship," where "cedar of Maine and Georgia pine/Here together shall combine":

> Day by day the vessel grew,
> With timbers fashioned strong and true,
> Stemson and keelson and sternson-knee,
> Till, framed with perfect symmetry,
> A skeleton ship rose up to view!

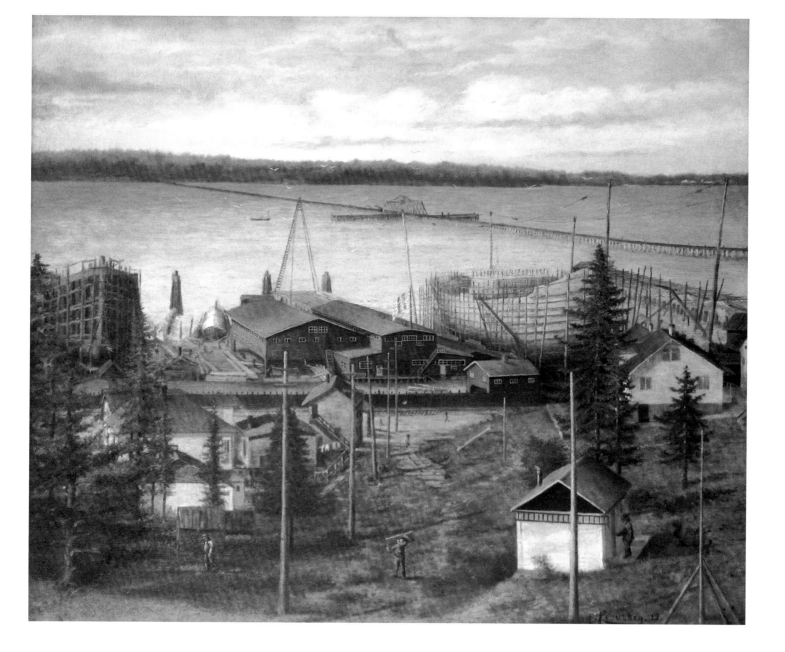

The painter Nicholas Winfield Scott Leighton (1847–1898) gained acclaim for his portraits of horses, including famous racing steeds of the time (Currier and Ives made prints from his paintings). The horse in his 1869 painting of Tom "Piggy" Huston, a Portland butcher, is decidedly of a lesser pedigree, a humble creature shown pulling two dead pigs on a sled in front of the old City Hall while another colorful character, Squire Jonathan Morgan, heads in the opposite direction.

Nicholas Winfield
Scott Leighton
Tom (Piggy) Huston,
Market Square, Port-
land, Maine
Oil on canvas, 1869
10 by 14¼ inches
Collections of Maine
Historical Society

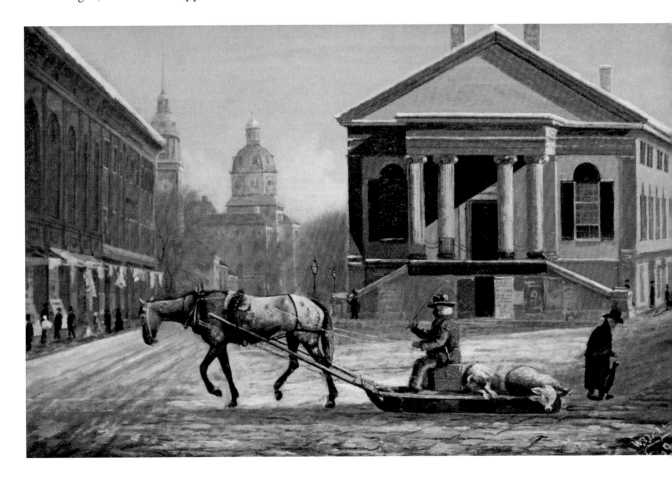

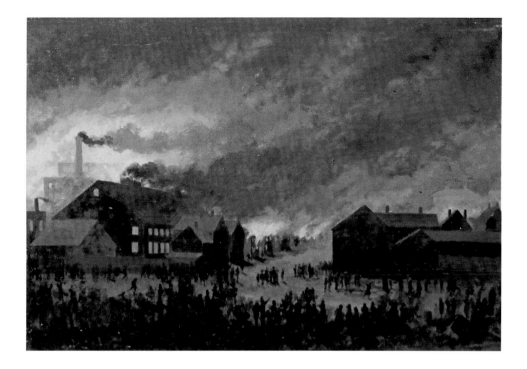

George Frederick
Morse
*Painting of Great Fire,
Portland (from
Richardson's Wharf)*
Oil on canvas, 1866
18 by 24½ inches
Collections of Maine
Historical Society

George Frederick Morse's depictions of the Great Fire of Portland in 1866 highlight that devastating conflagration. Around 1,800 buildings were destroyed and thousands lost their homes. Visiting the city soon after, Longfellow wrote, "Desolation! It reminds me of Pompeii, the 'sepult city.'" In "Flames Over Portland," the catalogue for F.O. Bailey's 1980 exhibition of Morse's fire panels, historian Earle G. Shettleworth Jr. noted how they "reach out to us across more than a century with an awesome immediacy and intensity that neither photograph nor written word could ever have hoped to capture."

In addition to being a draftsman and superintendent of the Portland Company, Morse (1834–1925) served as president of the Portland Society of Art, located in the Lorenzo de Medici Sweat Memorial Art Museum, the predecessor to the Portland Museum of Art. He also was a founding member of the Brush'uns, "a small group of business men who spent their Sundays out of doors transferring to canvas the scenes on land and sea," as the writer of Morse's obituary put it.

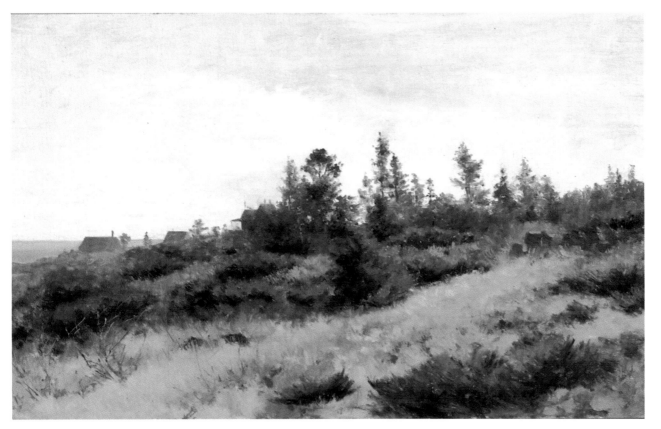

John Calvin Stevens
*Marsh Near Pond Cove
School, Cape Elizabeth*
Oil on canvas, 1910
14 by 18 inches
Photo Jay York
Collection Mr. and Mrs.
J. Alden Philbrick IV

George Frederick
Morse
View in Cape Elizabeth
Oil on canvas, no date
14 by 24 inches
Photo Jay York
Courtesy Barridoff
Galleries

These ardent plein-air painters from the Portland area took to the countryside and the sea, to marshes and secluded coves, easels and sun umbrellas in hand. Many a Sunday they would meet up at Morse's home in Delano Park in Cape Elizabeth and set out for a day of brushwork, fun, and mischief. In a review of Morse's show at the Sweat Museum when he was in his eighties, a critic wrote that his Maine pictures "are soft and gracious in coloring."

Among the most notable of the Brush'un cohort was the architect John Calvin Stevens (1855–1940), a major proponent of Shingle style and Colonial Revival design. Aside from a few forays to Boston and abroad, Stevens was a lifelong resident of the city. A civic leader, he also played a key role in creating what today we would call the "creative economy,"

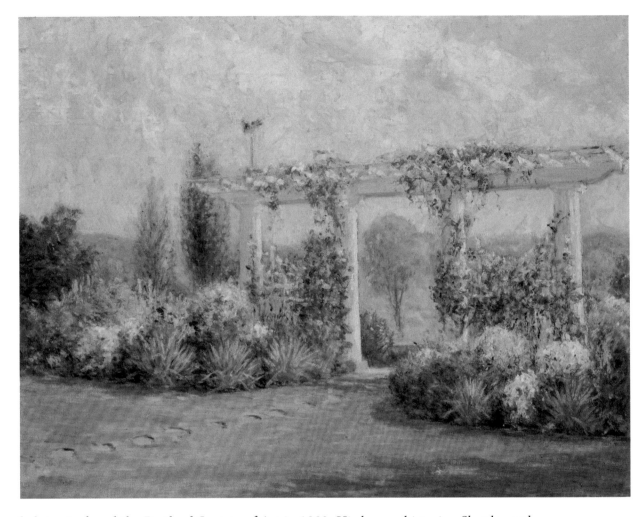

helping to found the Portland Society of Art in 1882. His legacy, historian Shettleworth states in *The Paintings of John Calvin Stevens*, lies in "the hundreds of widely admired homes and buildings he designed, in the impressive body of art work that he created, and in two major art institutions, the Portland Museum of Art and the Maine College of Art."

William Wallace
Gilchrist Jr.
*Congress Square in
Winter*
Oil on canvas, ca.
1925
20 by 26 inches
Portland Museum
of Art

That body of art work was indeed impressive—and impressionist. Guided by the examples of Winslow Homer and the Ten American Painters, the Boston group that included Childe Hassam, F. W. Benson, and Willard Metcalf, Stevens painted the landscape with flair. Subjects included a marsh near the Pond Cove School in Cape Elizabeth and his garden on Craigie Street. About the latter, one commentator at the time noted, "no one, but a true artist, would ever have brought to such a state of perfection a garden so beautiful."

A number of other turn-of-the-19th-century painters active in the Portland area practiced varieties of American Impressionism. William Wallace Gilchrist Jr. (1879–1926) deployed dynamic diagonal strokes of paint to capture his impression of a snowstorm blowing across Congress Square, nearly obscuring the famous "flatiron" Hay Building. Gilchrist and his family spent their summers in East Harpswell and their winters in nearby Brunswick or Topsham, taking the trolley to Portland and Boston or making local excursions in the artist's Stutz Bearcat.

Walter Griffin (1861–1935) was influenced by European art trends. Returning to his home city of Portland in 1920 after spending thirty years abroad, Griffin focused on the Stroudwater section at the western edge of the city. His light-filled renderings of the river and surrounding countryside lend that part of Portland a stature comparable to what he had achieved in Old Lyme, Connecticut, painting alongside Hassam, Metcalf, Robert Vonnoh, and others.

Griffin was the youngest member of the Brush'uns, whom he once called "the pioneers of art in Portland." He recalled getting up at the crack of dawn to "walk many miles, carrying painting traps to the given rendezvous." When he wasn't out tramping, he frequented Portland's three art stores, Hale, Schumaker, and Cyrus Davis.

Walter Griffin
The Stroudwater River
Oil on canvas, ca.
1917
Portland Museum
of Art
Gift of Mrs. George J.
Johnston

Charles Frederick
Kimball
Marine Hospital
Oil on canvas, 1859
14 by 23 inches
Portland Museum of Art

Another prominent Brush'un, master cabinetmaker Charles Frederick Kimball (1831–1903), painted a variety of subjects in the Portland area, among them the Marine Hospital on Martin's Point in eastern Portland. Built in the late 1850s to care for sailors, today the building stands on the grounds of the Martin's Point Health Care campus. Kimball's rendering of the scene reflects the influence of the Hudson River School painters, who sought to represent the American sublime with "luminist" atmosphere and tonal color.

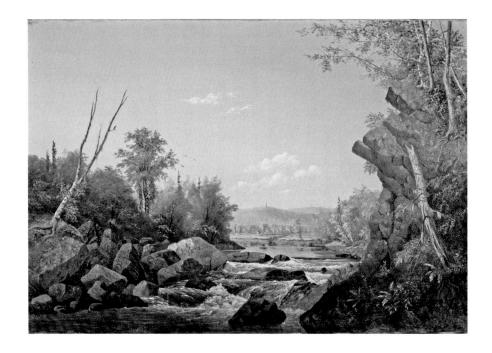

Kimball also chose sylvan subjects, such as a stretch of the Presumpscot River looking toward Blackstrap Hill in West Falmouth. His later work reflected the influence of the French Barbizon School. In a review of the 2003 exhibition *Charles Frederick Kimball, 1831–1903: Painting Portland's Legacy* in the *Portland Phoenix*, art writer Maggie Knowles notes that within the painter's pastoral landscapes "are reminders that with all the technology and industry that humans force upon the planet, there are still some things greater than our control."

Kimball sometimes went on outings with his friend and fellow painter John Bradley Hudson Jr. (1832–1903). The Portland native worked in oil and watercolor and specialized in panoramic images. His undated *White Head, Cushing Island, Maine* offers a view of the dramatic headland that was a favorite subject of Portland painters. Like their brethren who frequented Monhegan, they found dramatic cliffs set off against the sky and sea irresistible.

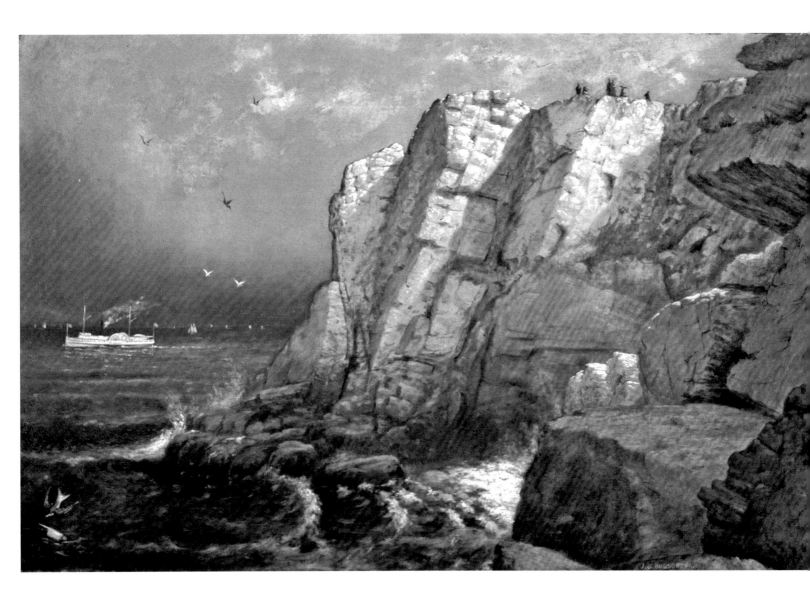

John Bradley Hudson Jr.
White Head, Cushing Island, Maine
Oil on canvas, no date
24 by 36⅛ inches
Portland Museum of Art

The Casco Bay islands became favorite destinations for artists and excursionists, the former often including the latter in their paintings. In Ira W. Hamilton's view of White Head, for example, men and women are shown taking in the view while sailboats and a steamboat cut across the water. Cushing Island offered lodging for tourists and came to be known as the "Newport of Casco Bay."

Hamilton was a contemporary of George M. Hathaway (1852–1903), a prolific painter of coastal scenes, many of them set among the Casco Bay islands. Hathaway had a summer studio on Peaks Island. In Conforti's *Creating Portland*, art historian Donna Cassidy notes that Hathaway provided illustrations for brochures and guidebooks and sold souvenir views of the area, which "added to the islands' appeal."

Ira W. Hamilton
White Head, Cushing Island
Oil on board, 1911
6¼ by 12 inches
Photo Jay York
Courtesy Barridoff Galleries

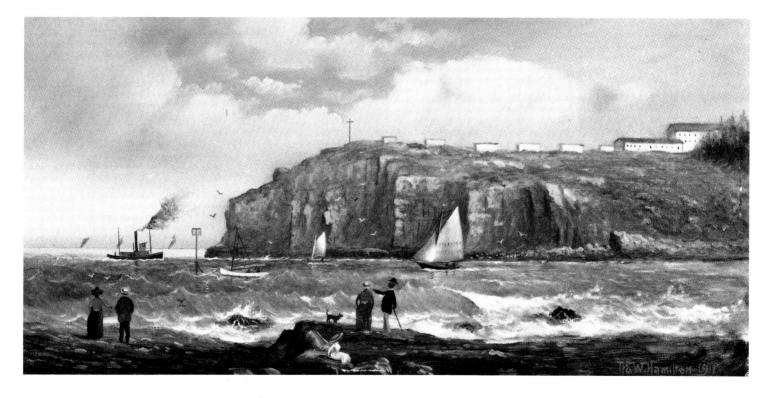

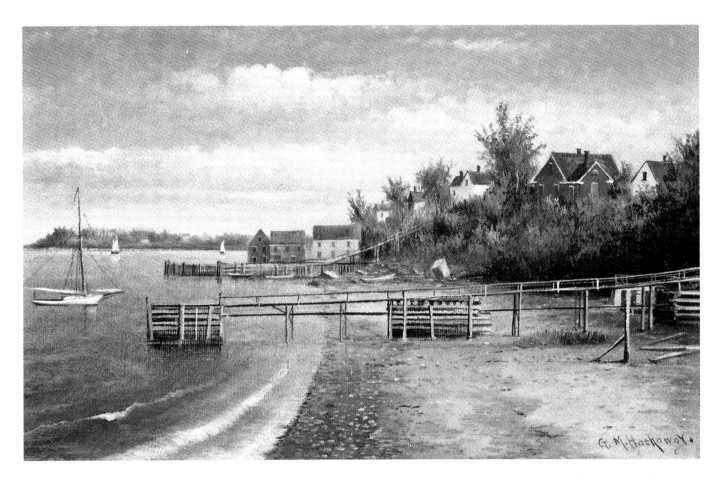

George M. Hathaway
Peaks Island
Oil on canvas, no date
9 by 14 inches
Photo Jay York
Courtesy Barridoff
Galleries

A view of Pleasant Cove on Diamond Island by John Greenleaf Cloudman (1813–1892) shows day-trippers enjoying an outing along the water, some picnicking, some rowing, and others sailing by in a sloop. A student of Charles Codman, Cloudman in turn taught Charles Kimball, who became his son-in-law upon marrying Cloudman's daughter Annie in 1863.

While the Brush'uns and other early Portland painters enjoyed artistic comradery, down the coast on Prout's Neck, Winslow Homer (1836–1910) preferred working by

himself, painting many of his late masterpieces in a studio that had been designed by John Calvin Stevens. Even so, as historian Cassidy has noted, "Homer's coast became a powerful image of Portland and in the twentieth century the dominant mode of representing the Maine coast for modernists like George Bellows, John Marin, and Marsden Hartley." The regional context for Homer's art may be found in his friendship with Stevens and in the Portland Society of Art's inclusion of his work in their collection and exhibitions.

John Greenleaf Cloudman
Pleasant Cove, Diamond Island, Casco Bay
Oil on twill canvas, 1869
26 by 50 $\frac{1}{16}$ inches
Portland Museum of Art

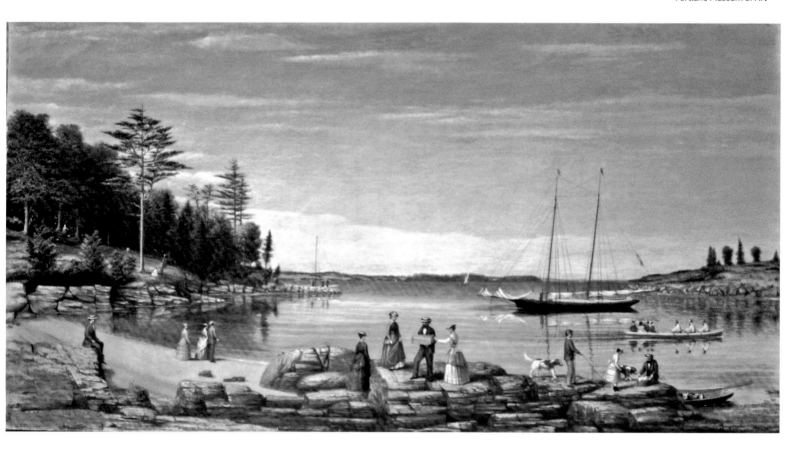

In his classic *Winslow Homer at Prout's Neck* (1966), Bowdoin College art historian Philip Beam recounts how the painting *The West Wind* helped the artist win a $100 wager with fellow painter John La Farge. La Farge had bet Homer that he couldn't paint a picture in browns that would be a popular success. *The West Wind* was a crowd-pleaser.

Winslow Homer
The West Wind
Oil on canvas, 1891
30 by 44 inches
Addison Gallery of
American Art
Gift of anonymous
donor, 1928.24

Homer shied away from the more picturesque elements of the coast, including light-houses. Such was not the case with Warren Sheppard (1858–1937), the marine artist whose *End of Day, Halfway Rock Light* presents a glowing sunset view of the lighthouse halfway between Cape Elizabeth and Cape Small. An expert navigator (his book *Practical Navigation*, 1920, has been reprinted a number of times), Sheppard often brought an on-the-ocean perspective to his romanticized seascapes.

Warren Sheppard
*End of Day, Halfway
Rock Light*
Oil on canvas, no date
19¾ by 30 inches
Photo Jay York
Courtesy Barridoff
Galleries

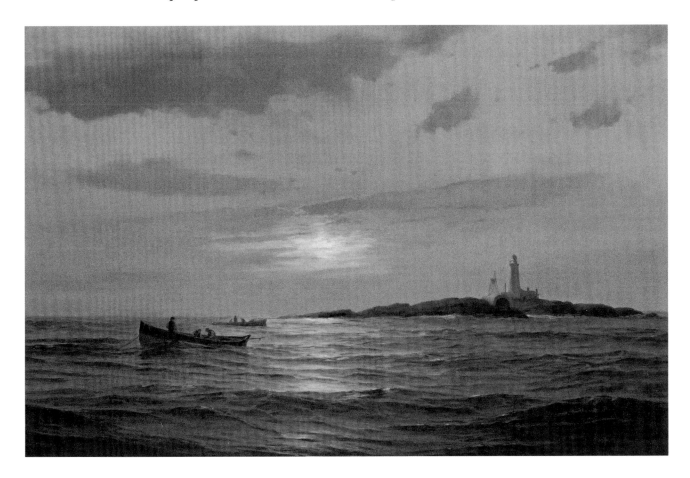

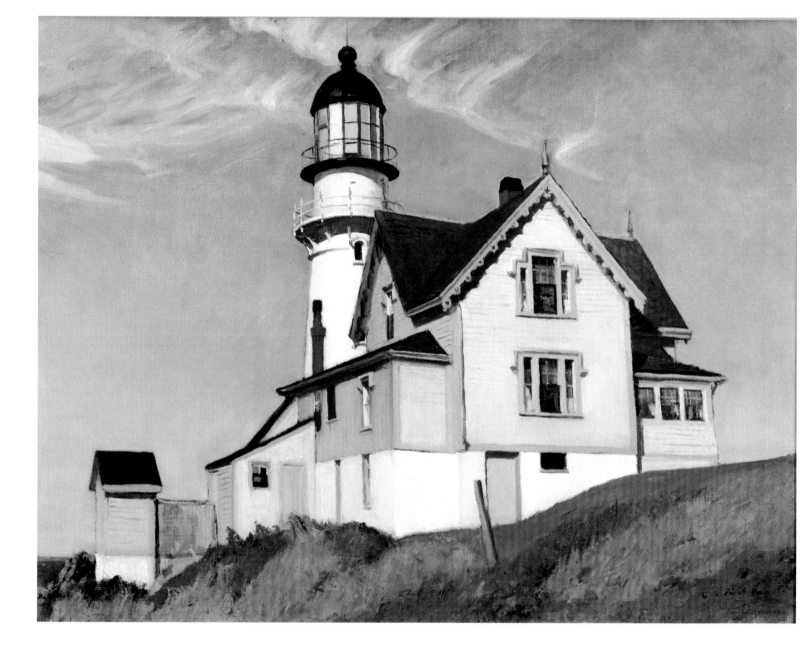

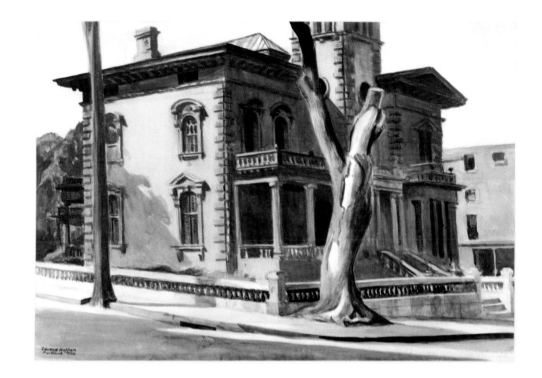

Edward Hopper
Captain Upton's House
Oil on canvas, 1927
28 by 36 inches
Private collection,
courtesy Bowdoin
College Museum of
Art

Edward Hopper
*Libby House, Portland,
Maine*
Watercolor over
graphite on paper,
1927
13 $7/8$ by 19 $15/16$ inches
Fogg Museum,
Harvard Art Museums,
1927.257

The crown for Maine lighthouse paintings belongs to Edward Hopper (1882–1967); his oils and watercolors of Portland Head Light and Two Lights at Cape Elizabeth stand among the best-known images of the subject. One of them, *Captain Upton's House*, 1927, offers a dramatic skyward view of the buildings of the eastern lighthouse complex at Two Lights. Describing the "five angled plates of glass" at the top of the beacon, comedian and collector Steve Martin writes in *Edward Hopper's Maine* (2011), "A gifted narrator with pen or voice could not tell a more thorough story of an afternoon sun than Hopper does with this color wheel of lighthouse glass."

Hopper and his wife, painter Josephine Nivison, traveled from New York City to Portland by car, a used 1925 Dodge, in the late 1920s. He made watercolors of several notable buildings, including the Customs House and the Libby Mansion, which later became the Victoria Mansion, one of the most visited historical structures in the city.

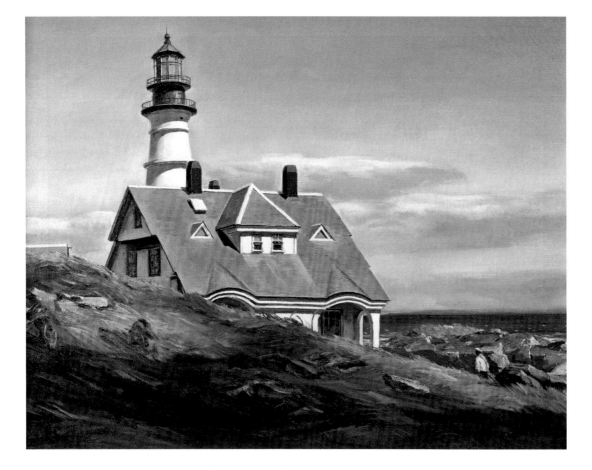

Andrew George Winter
Portland Head Lighthouse, 1938
Oil on canvas
22 by 28 inches
Courtesy Jeffrey Tilou Antiques

The artist Andrew Winter (1893–1958), who had moved to America from his native Estonia around 1920, took a break from working on Monhegan Island to paint the Portland Head Light in 1938. The lighthouse, completed in 1791, stands on a rocky promontory in Cape Elizabeth overlooking the primary entrance to Portland Harbor. Winter's painting includes the lighthouse keeper's residence, which now houses a maritime museum as part of Fort Williams Park. From Harrison Bird Brown to Marsden Hartley to the painters of today, the subject of Portland Head Light, although clichéd and commercialized, remains among the most popular motifs in the greater Portland area.

In Alexander Bower's circa 1921 painting of Two Lights, the beacons are barely visible in the distance. Born in New York and trained in Philadelphia, Bower (1875–1952) first visited Maine in the nineteen-teens, eventually building a home near Beckett Castle in Delano Park on Cape Elizabeth. He served as director of the Portland School of Fine and Applied Art and the L. D. M. Sweat Memorial Art Museum from 1931 to 1951.

Alexander Bower
(1921)
Two Lights
Oil on canvas, 1921
40 by 48 inches
Photo Jay York
Courtesy Barridoff
Galleries

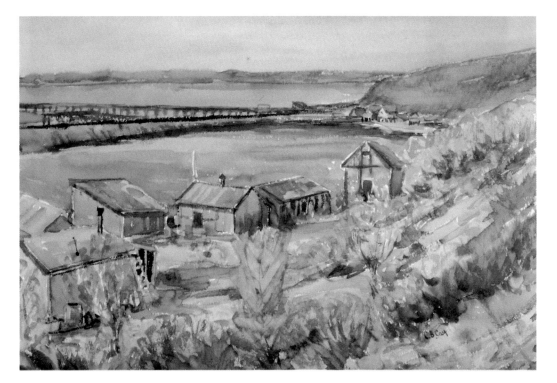

Charles Bailey Cook
*View of Back Bay from
Shanty Town, Portland*
Watercolor, no date
14 by 21 inches
Photo Jay York
Courtesy Barridoff
Galleries

Xanthus Smith
*Camouflaged Ships,
Casco Bay*
Oil on canvas, 1918
6½ by 10 inches
Collections of Maine
Historical Society

Among the most unusual maritime images is a 1918 watercolor of camouflaged ships in Casco Bay by Philadelphian Xanthus Smith (1839–1929). Built during World War I, these brightly colored battleships, painted in a style called "dazzle" or "razzle dazzle," must have been a sight out on the water. In a curious manner their abstract-geometric designs, meant to confuse submarines and other ships, anticipate the creative vision of Venezuelan Jaime Gili, who transformed the Sprague Energy tank farm in South Portland into one of the world's largest public art projects.

Like the rest of America, Maine experienced the Great Depression. Portland's Back Bay dump became Shanty Town, a place where jobless men and their families lived until the late 1930s, when it was cleared to make Marginal Way more pleasant for passing motorists. An undated watercolor by Charles Bailey Cook (1865–1948) shows a part of the ramshackle town.

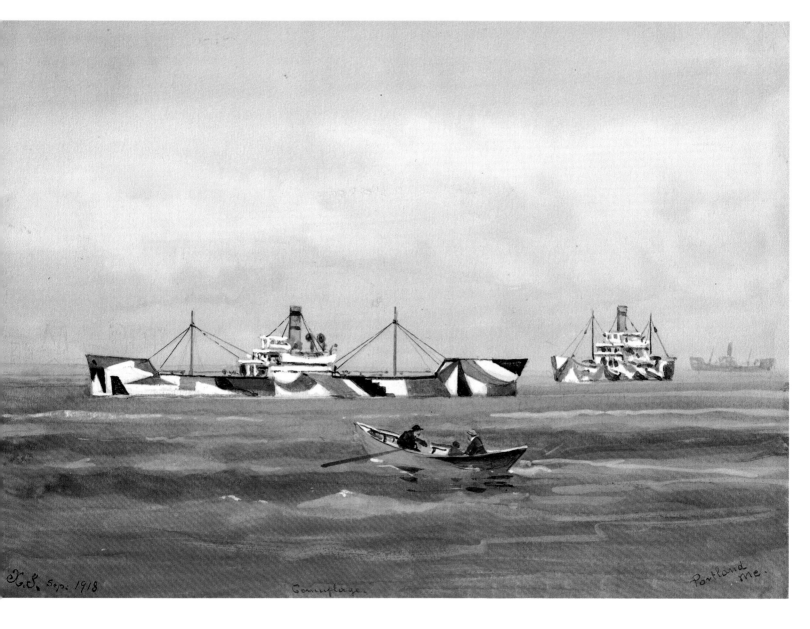

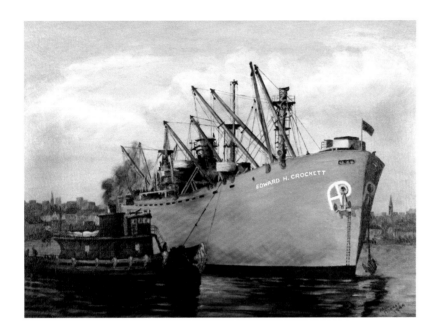

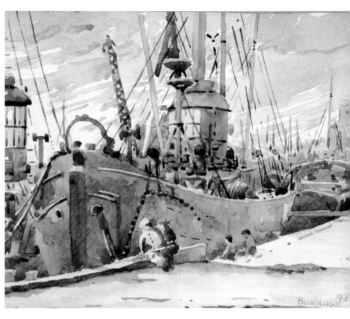

Jumping to World War II, artist Paul Murray used a photograph from a newspaper as a guide in painting a Liberty Ship being launched from a dock in South Portland by the New England Shipbuilding Corporation. The ship was named for Associated Press correspondent Edward H. Crockett, who died in the war. Other Liberty ships built at the shipyard bore the names of famous Mainers, including Joshua Chamberlain, Sarah Orne Jewett, and Winslow Homer.

During the Second World War, the many-talented Mildred Burrage (1890–1983) worked as a counselor to women employed at the South Portland Shipyard. "The only way to preserve democracy is to fight for it—as a volunteer," Burrage wrote in a letter to the *Portland Press Herald*. In addition to designing safety posters, she made watercolors of the busy waterfront.

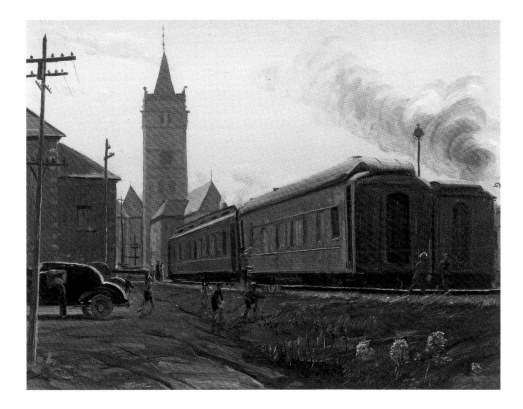

Stephen Etnier
Union Station
Oil on canvas, 1941
28 by 36 inches
Photo Jay York
Courtesy Barridoff
Galleries

In 1941, Stephen Etnier (1903–1984), that renowned painter of the Maine coast, turned his attention to one of Portland's most notable architectural structures, Union Station. Completed in 1888, this grand railroad terminal, with its picturesque French chateau-style exterior and noble 125-foot-tall clock tower, looms over the smoky railyards in Etnier's painting.

The building's demolition in 1961 would spur a movement to preserve Portland's architectural heritage that goes on to this day. As Conforti notes in *Creating Portland*, "Images of Union Station have served as more than a memorial to past grandeur; they have been a summons to safeguard the architectural heritage that distinguishes Portland as a place." Among those who have answered the call are today's painters, their work recording— and thereby preserving—a city on two hills.

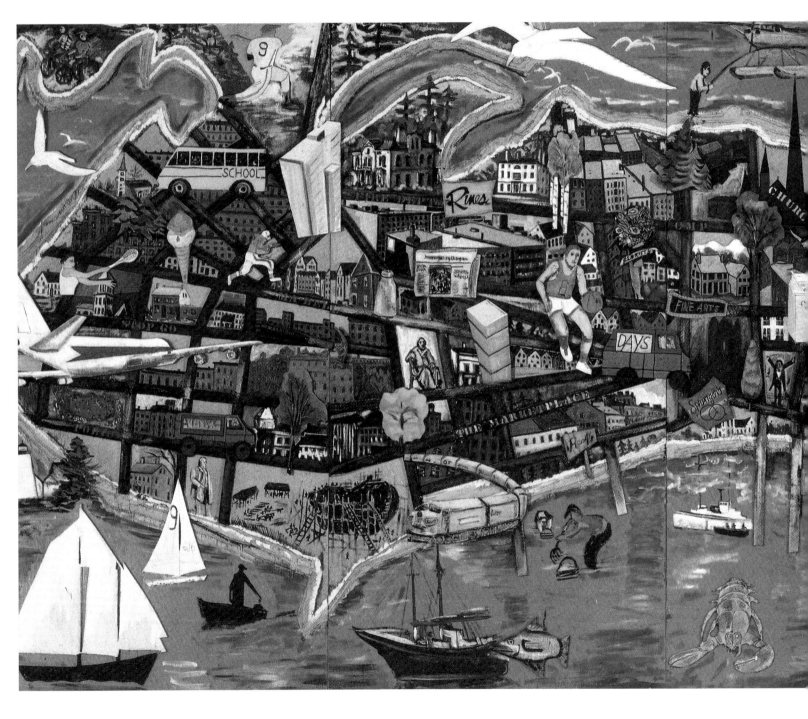

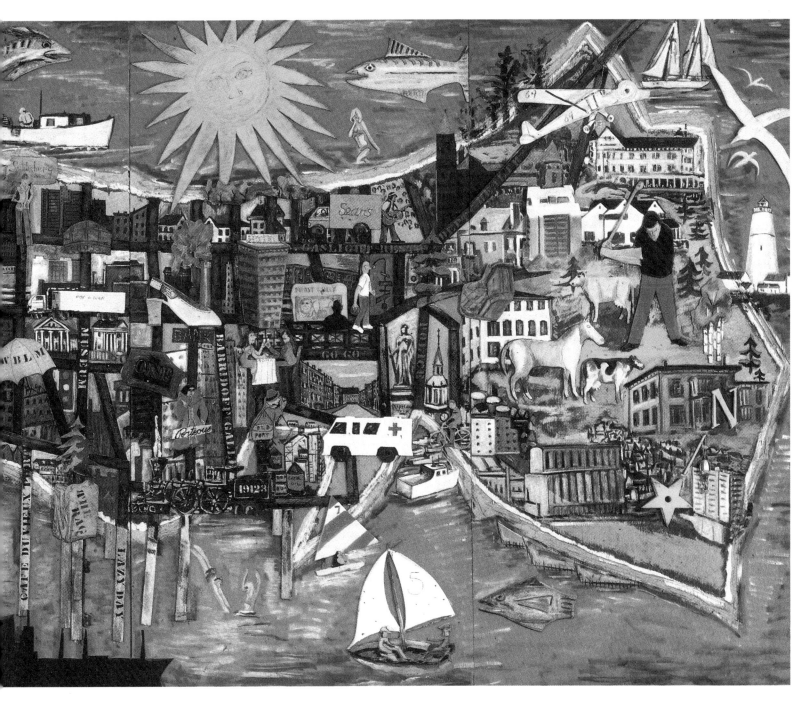

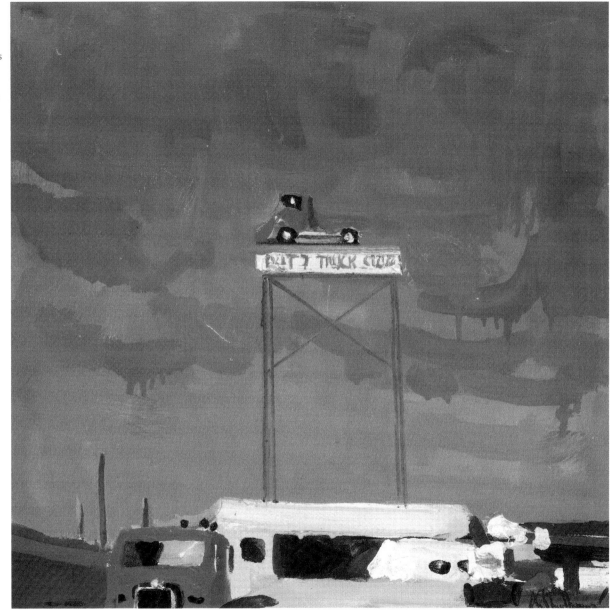

OVERLEAF:
Bernard Langlais
Portland
Painted wood
relief, mid-1970s
8 by 20 feet
Photo Bill
Bentley
KeyBank
Collection

Paintings *of* Portland:
THE PRESENT

"Portland retains a comfortable mix of contemporary urban culture, working industrial seaport, and commercial center.... Contrasts of new and old, class and station, artificial and real, all enter into an exciting mosaic. Casco Bay and raw nature are set at the edges, acting as a foil. A T. S. Eliot sense of time past, present, and future pervades the luminous atmosphere."

—Nathaniel Larrabee, cited in
Creating Portland, 2005

Alfred Chadbourn
Welcome to Portland
Oil on canvas, 1980s
14 by 13¾ inches
Photo Bill Bentley
KeyBank Collection

In his monumental five-panel wood relief *Portland*, Bernard "Blackie" Langlais (1921–1977) carved, nailed, glued, and painted a wondrous collage-like representation of the city. The Old Town, Maine-born sculptor managed to fit all sorts of things onto one busy peninsula: buildings and businesses, famous landmarks, athletes and fishermen, planes, boats, a school bus, and an ambulance—all jam-packed into a zany yet sophisticated design. Representing 1970s Portland, Langlais included Frost Gully Gallery, the Fine Arts District, Barridoff Galleries, and the Porteous department store, future home of the Maine College of Art. It is a spectacular homage to a remarkable place.

Alfred Chadbourn
B & M Beans
Oil on canvas, 1991
16 by 16 inches
Photo Jay York
Courtesy Barridoff
Galleries

Around the time Langlais was creating this magnum urban opus, another sophisticated arranger, painter, and influential teacher, Alfred "Chip" Chadbourn (1921–1998), was exploring his adopted state from his home in Yarmouth. He painted scenes in and around Portland, from the Exit 7 Truck Stop sign on Fox Street to the B & M Plant on Route 1 and the view of the city's skyline from Marginal Way. Chadbourn's painterly approach gives these views an appealing immediacy, as do his strong color and simplified designs.

Alfred Chadbourn
Marginal Way
Oil on canvas, 1970
12 by 16 inches
Photo Jay York
Courtesy Barridoff
Galleries

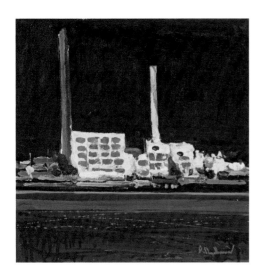

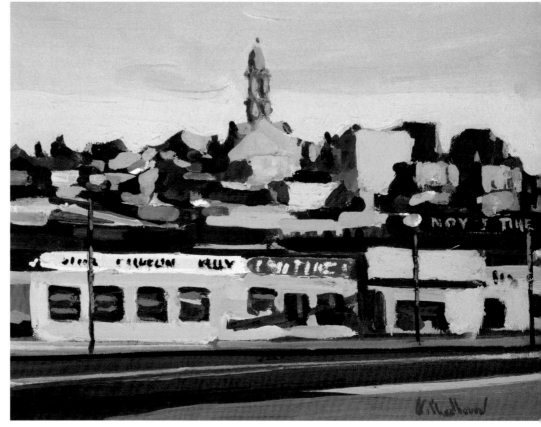

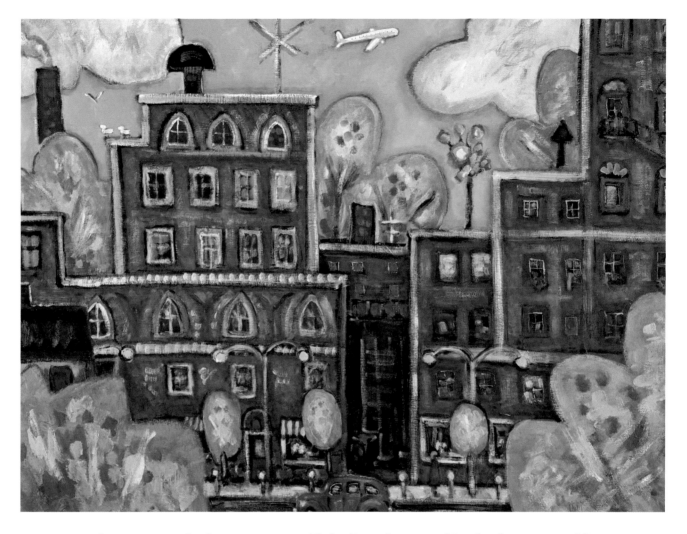

A similar energy marks downeast painter Philip Barter's image of Portland streets. In his mission to paint his home state of Maine, Barter has taken on the big city on several occasions, drawn to its structural density and action. As in the Langlais work, a plane in the sky overhead is a reminder of the busy Portland International Jetport southwest of the city.

Philip Barter
Bricks and Trees (Port-land Streets)
Acrylic on board, 2008
30 by 40 inches
Courtesy Courthouse
Gallery Fine Art

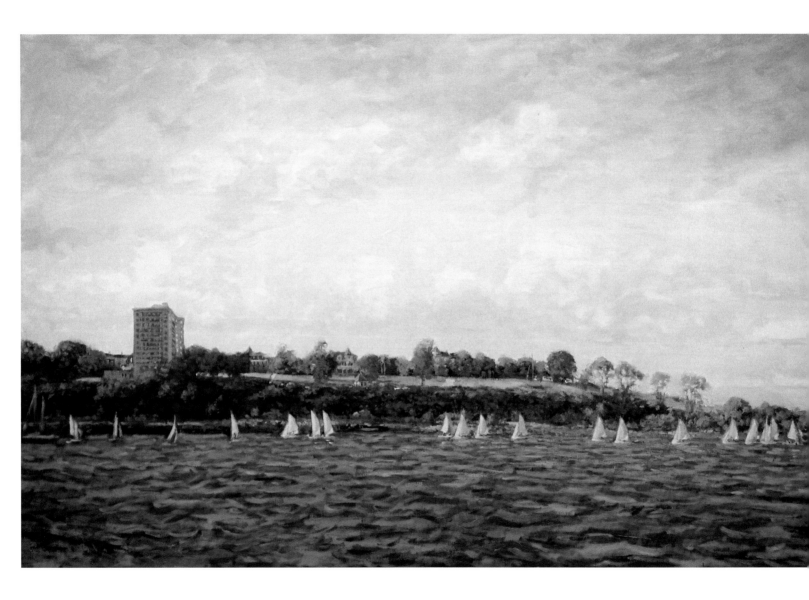

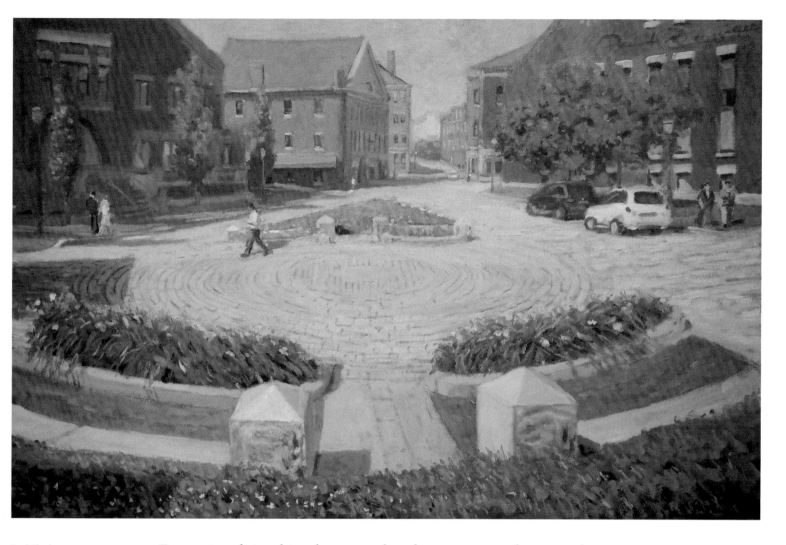

Paul Black
Regatta, Eastern Prom
Oil on canvas, 2012
24 by 36 inches
Courtesy Paul Black
Studio

Every painter brings his or her own style and temperament to bear in rendering Portland. Case in point: Paul Black (1951–2014). After moving to the city in 1987, Black employed his latter-day impressionist style to render a variety of views of the city, from a fleet of 420-class sailing dinghies passing the Eastern Prom to views of Portland's Old Port

Paul Black
Boothby Square
Oil on canvas, 2013
20 by 30 inches
Courtesy Paul Black
Studio

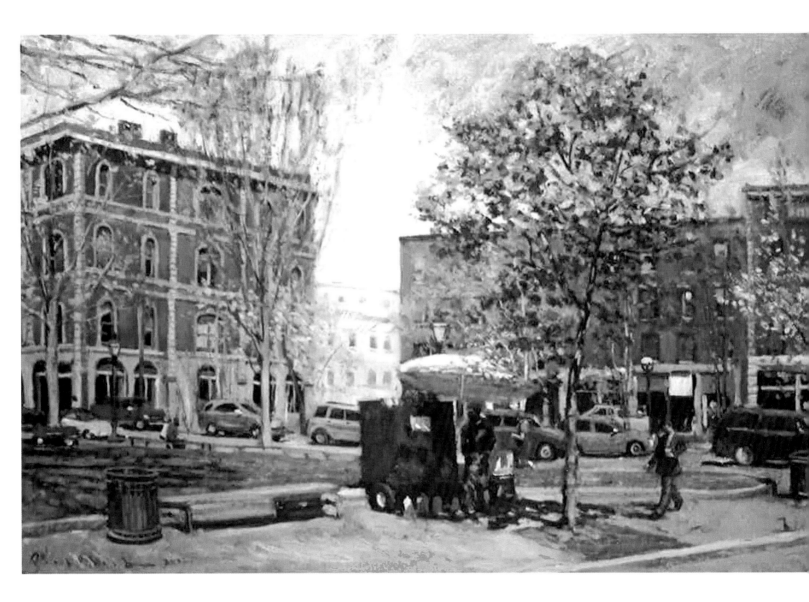

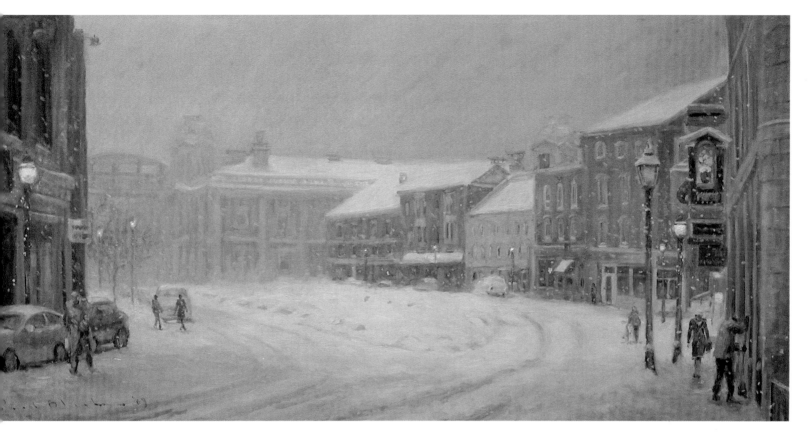

Paul Black
Tommy's Park, Middle and Exchange
Oil on canvas, 2012
24 by 36 inches
Courtesy Paul Black Studio

and Tommy's Park with its mainstay, Mark Gatti's hotdog cart. In his best-known views of Portland's Old Port in winter, he was able to capture the charm of snowy evenings, with street lamps, storefronts, and the occasional shopper adding a sense of timelessness.

Paul Black
Portland Old Port
Oil on canvas, 2014
24 by 48 inches
Courtesy Paul Black Studio

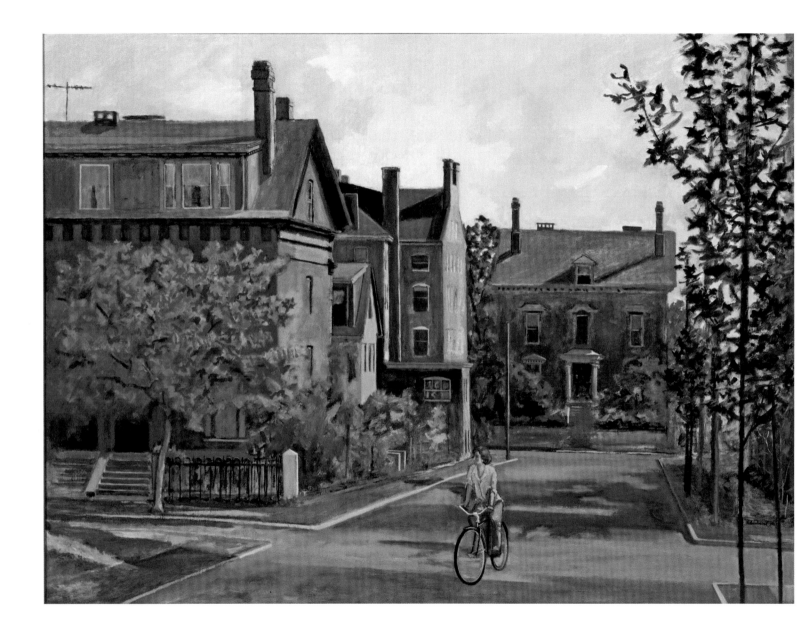

Robert Solotaire
Gray Street View,
Portland, Maine
Oil on canvas, 1979
30 by 40 inches
Photo Jay York
Courtesy Barridoff
Galleries

Robert Solotaire (1930–2008) was likewise smitten with the city. A New Yorker by birth (his father ran a theater ticket agency in Times Square), he thoughtfully and carefully painted different parts of Portland. His painting of Gray Street offers an image of a quiet thoroughfare in the West End. By contrast, *Passage* places us in the middle of the Franklin Arterial. Both paintings convey the artist's affection for Portland, for its residential and industrial sections.

Robert Solotaire
Passage
Oil on paper, 1990
13 by 29 inches
Photo Jay York
Courtesy Barridoff
Galleries

David Campbell
E. Perry Iron & Metal Co.
Oil on panel,
2011–2012
22 by 49 inches
Photo Jay York
Private collection

Not all is picturesque in Portland. Take the gritty realism displayed in David Campbell's painting of the E. Perry Iron and Metal Company on Lancaster Street. Tangled heaps of scrap metal contrast with the neatly ranked trailer trucks of Oakhurst Dairy and United Moving Company. Campbell completed the Bayside canvas over two summers, working from a nearby parking garage.

Campbell specializes in cityscapes. A plein-air painter and "slow worker," he revels in the opportunity to paint Portland in all seasons. His *Autumn on Munjoy Hill* depicts a group of dog owners enjoying an outing on one of the city's most prominent points.

David Campbell
Autumn on Munjoy Hill
Oil on panel,
2003–2008
Photo Jay York
Traub Collection

constructed between 1867 and 1872, includes the waterfront and Peaks Island in the background.

Donahue, who lives in Millinocket, loves the variety of landscapes in Portland, which, she says, "has it all . . . from hillsides with old brick housing to gritty industrial waterfront to homey suburban neighborhoods to wide open vistas with islands dotting the harbor." While she has painted in the city since the late 1960s, she finds Portland's neighborhoods, the Old Port, and waterfront architecture and activities consistently "interesting and challenging."

Marsha Donahue
Mending the Nets
Watercolor, 2013
22 by 30 inches
Collection Synergent

Cooper Dragonette
Portland Alley
Oil on panel, 2017
14 by 10 inches
Private collection

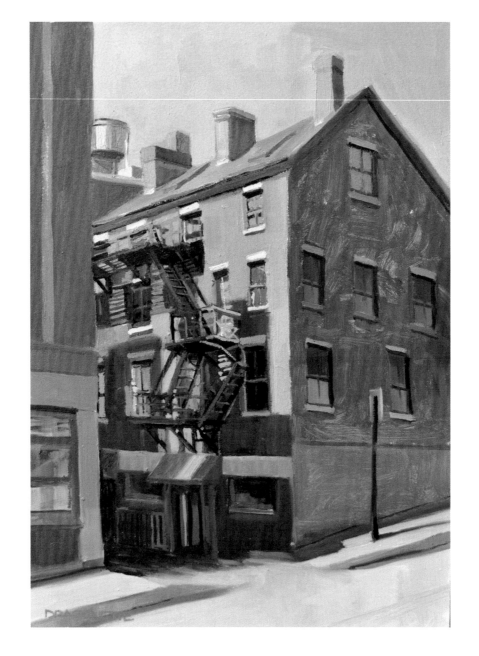

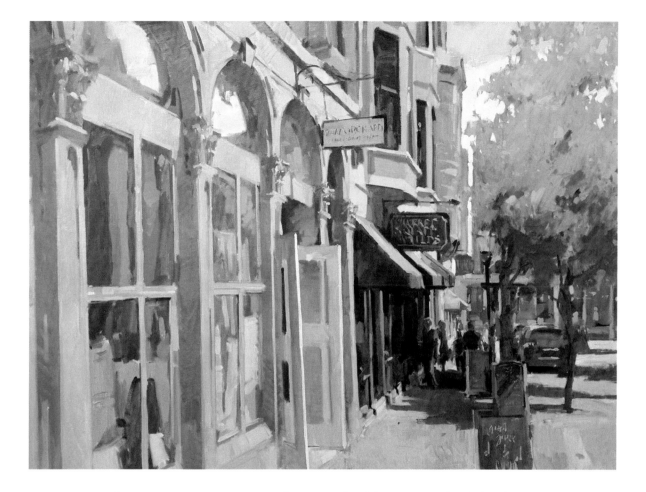

Colin Page
Exchange Street
Oil on canvas, 2017
36 by 48 inches
Courtesy Greenhut
Galleries

So does Cooper Dragonette. For his view of Gold Street, an alley behind Commercial Street in the Old Port, the painter from Cape Elizabeth set up his easel on the west side of the Customs House on Pearl Street. He was attracted to the shadows and patterns created by the fire escape that climbs the building.

Colin Page, who is based in Camden, Maine, uses a looser approach and strong color values to build structural depth in his rendering of the sunlit shop fronts along Exchange Street. A different play of light marks Portland native Peter Rolfe's painting of Boothby

Peter Rolfe
Fore St. and Silver,
Portland
Oil on canvas, 1998
30 by 40 inches
Courtesy the artist

Square, which he began working on from under two sun-blocking umbrellas and completed in his studio. Both painters seek to represent the dazzle of downtown through a rhythmic fracturing of space.

Painter Alison Rector has had a very specific focus for her architectural studies: public libraries. Since painting the view of Back Cove from the Albert Brenner Glickman Family Library at the University of Southern Maine in 2007, Rector has created more than forty paintings of libraries, quiet spaces she invites us to visit from inside and out. In her view of the original Portland Public Library on Congress Street, late afternoon sunlight casts a shadow across the Romanesque Revival structure, which was designed by Francis H. Fassett and built as a gift to the city by philanthropist James Phinney Baxter in 1882. Today some of the Baxter Building's interior has been reimagined by the VIA advertising agency.

Alison Rector
Back Cove Evening
Oil on linen, 2007
22 by 28 inches
Photo Jay York
Private collection

Alison Rector
The Original Portland
Public Library
Oil on linen, 2016
10 by 14 inches
Photo Jay York
Private collection

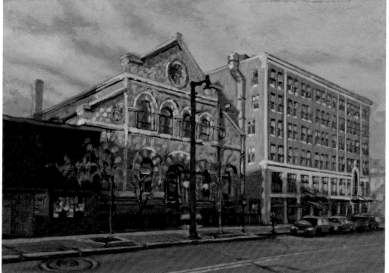

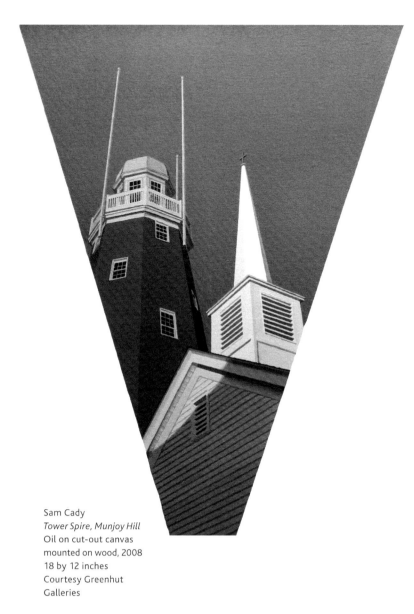

Sam Cady
Tower Spire, Munjoy Hill
Oil on cut-out canvas
mounted on wood, 2008
18 by 12 inches
Courtesy Greenhut
Galleries

With its distinctive red shingles, placement atop Munjoy Hill on Congress Street, and striking shape, the eighty-six-foot-tall octagonal Portland Observatory, designated a National Historic Landmark in 2006, has attracted many artists. A photograph of the structure taken by Bruce Brown, longtime Portland resident and one of the pillars of Maine's contemporary art scene, inspired Friendship-based painter Sam Cady, who used a shaped canvas in order "to open up the energy of the sky."

Over the years Thomas Connolly has produced a stunning inventory of Portland buildings and street scenes—cityscape portraits of the first order. He pays tribute to the "pride and care" that it took to build some of the city's landmark structures. His painting of the four-story brick Rackleff Building in the Old Port, designed by George M. Harding and built in 1867, features the distinctive iron pilasters and arches and the Second Empire mansard roof.

Connolly's *Greenhut* includes the iconic blue neon wave-like squiggle that marks the entrance to the well-known gallery at the corner of Middle and Pearl Streets. Originally located on Fore Street, the gallery moved to the Storer Brothers Building in 1986 after a fire in the Mariner's Church Building.

Thomas Connolly
Middle Pearl
Oil on panel, 2001
48 by 36 inches
Collection John
Golden

Thomas Connolly
Greenhut
Oil on panel, 2010
28 by 24 inches
Photo Dorrance
Studio
Collection Peggy
Greenhut Golden

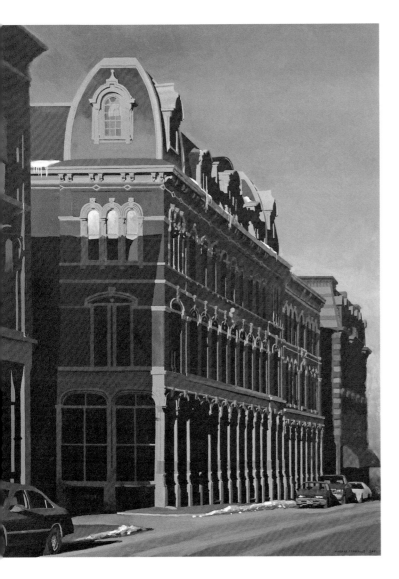

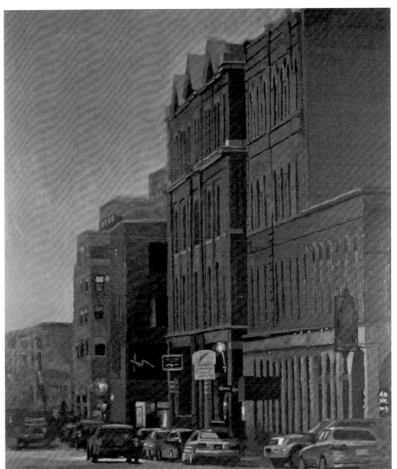

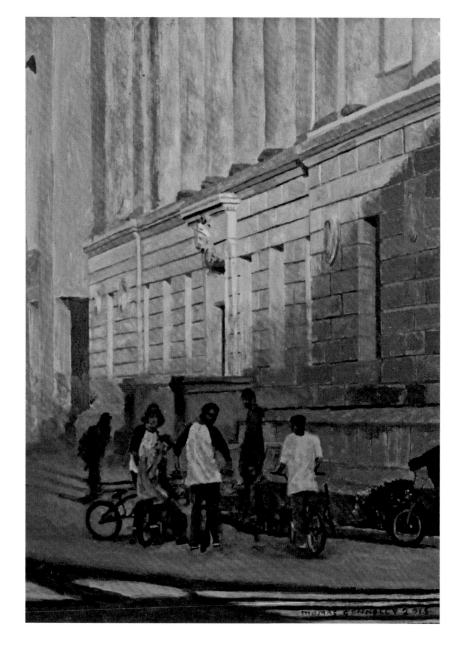

Occasionally Connolly will include figures, as in *KRC*, which features a group of boys with bicycles gathered near the entrance to the courthouse on Federal Street. One of them is the artist's son, Kyle Richards-Connolly, the KRC of the title. "Before they got driver's licenses or jobs," Connolly explains, "they would ride all day long throughout the year and especially during the summer months," forming a special bond.

Belfast-based Linden Frederick rarely includes figures in his paintings, but often uses a "surrogate"—a car or store mannequin or, as in *Watcher*, a view telescope that has a distinctly human appearance. Instead of looking out on the waters of Casco Bay, the telescope appears to be watching Portland House, an apartment building on the Eastern Prom.

Thomas Connolly
KRC Biker
Oil on panel, 2016
16 by 22 inches
Collection Kyle
Richards-Connolly

Linden Frederick
Watcher
Oil on linen, 2006
45 by 45 inches
Courtesy Forum
Gallery

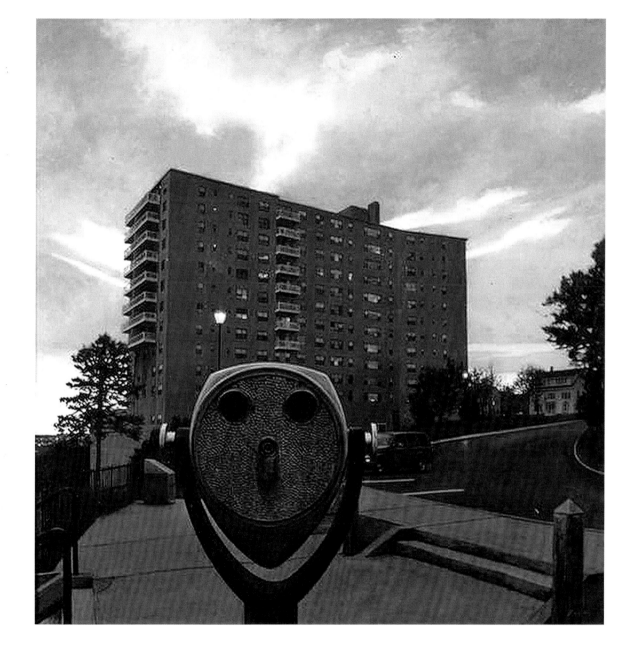

C. Michael Lewis
Justice
Acrylic on board, 1993
24 by 16 inches
Collection Ted and
Lucinda Hart

C. Michael Lewis
State Theater
Acrylic on board, 1988
36 by 24 inches
Collection Peter
Murray

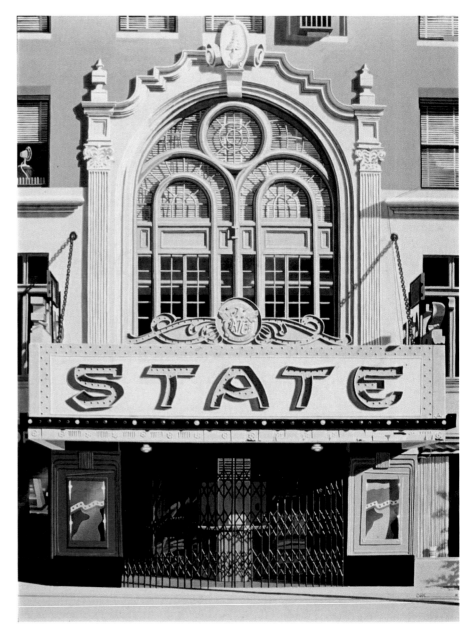

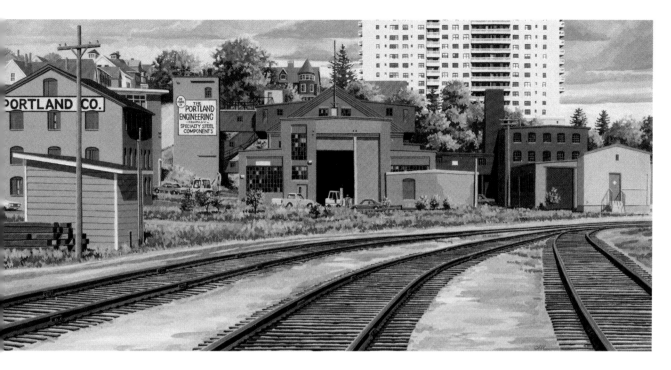

C. Michael Lewis
Portland Company
Acrylic on board, 1988
23 by 48 inches
Photo Bill Bentley
Collection KeyBank

Portland is full of wonderful architectural details, some of which C. Michael Lewis painted as part of a scavenger hunt for Greater Portland Landmarks in 1993. One of them, the visage of Justice, looks down over the entrance to the Cumberland County Courthouse on Federal Street.

A resident of downtown Portland, Lewis grew up in the city, training as an architectural and engineering draftsman. His skill with line, compositional detail, and cool color palette can be seen in his jazzy rendering of the ornate marquee of the State Theater on Congress Street. He also found inspiration in the railyard below Portland House where the Maine Narrow Gauge Railroad Co. and Museum presents the history of the Portland Company, a major steel foundry for locomotives, railcars, automobiles, and merchant marine and naval vessels.

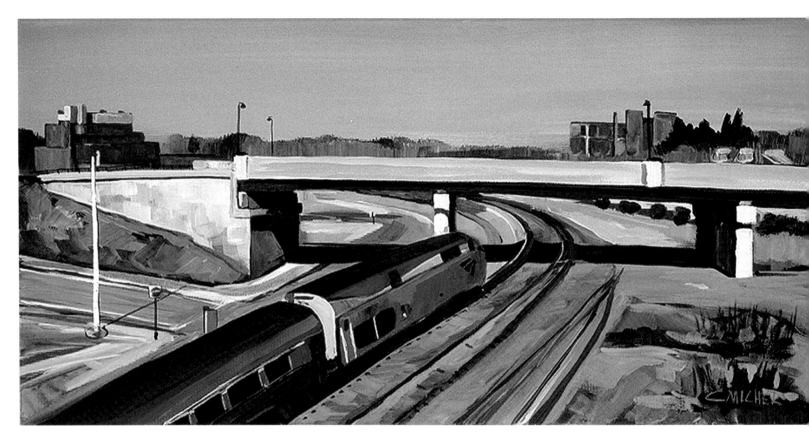

Caren-Marie Michel
The Downeaster
Acrylic on canvas,
2012
12 by 24 inches
Photo Jay York
Courtesy Littlefield
Gallery

Today, visitors can arrive in the city via the Amtrak Downeaster, which made its first run between Portland and Boston on December 15, 2001, after a thirty-four-year interruption of service. Caren-Marie Michel's painting of the Downeaster is based on a photo taken on a cold and sunny February day in 2012. She was drawn to the energy of the scene, "the directional lines and the contrast of the cool blues and silver of the train, and the dead ground colors of late winter." Michel's colorful painting of Artist & Craftsman Supply off Forest Avenue is fittingly titled *Got Paint*.

Caren-Marie Michel
Got Paint
Acrylic on canvas,
2007
6 by 12 inches
Photo Jay York
Private collection

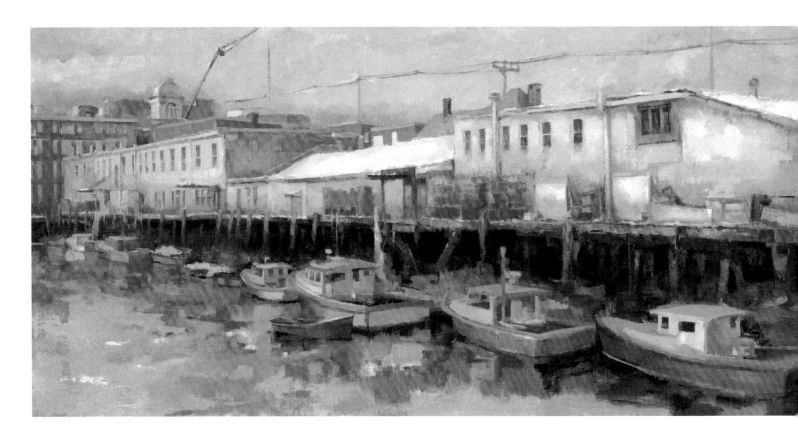

Tina Ingraham
Early Snow
Oil on mounted linen,
2010
32 by 64 inches
Photo Ken Woisard
Collection Tony and
Elizabeth Minella

Painters explore Portland's busy, multiuse waterfront, and some, like Tina Ingraham, are obsessed with certain motifs found there. Since 2004 the Bath-based artist has been visiting Custom House Wharf to paint on-site. She is inspired by, and believes in, "that place, its space, its weathering facade, yearly repairs, and comings and goings of persevering fishermen and fishmongers." In *Early Snow*, one of about forty paintings of the subject, the lobster boats are docked early in the day because of winter weather on its way.

A resident of Brooklyn, New York, who once painted murals for the Metropolitan Opera, Jeff Bye has an appreciation for the character of urban settings. In his wide-angle view of the Custom House Wharf, he includes a bit of graffiti, adding a modern touch to an already richly layered scene. Both his and Ingraham's interpretation of the wharf invites an ecocritical dialogue about the viability of the "working waterfront" and the tenacity of the fishing community.

Jeff Bye
Old Port
Oil on linen, 2016
28 by 46 inches
Courtesy Greenhut Galleries

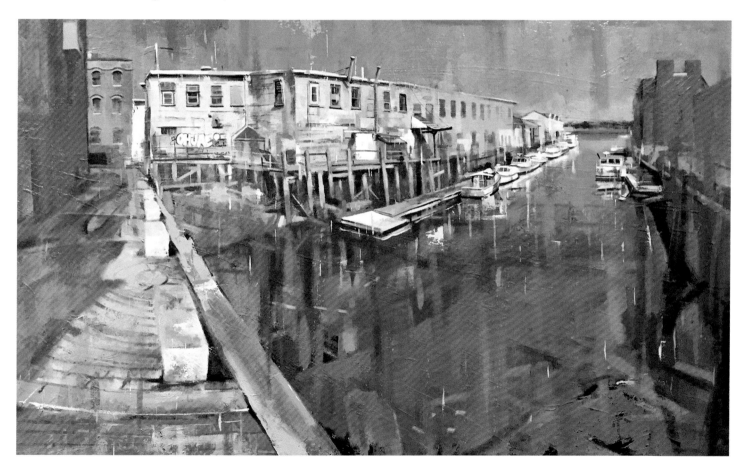

Rush Brown
*A Cruise Ship in the
Neighborhood*
Oil on wood panel,
2008
16 by 20 inches
Collection of the artist
Courtesy Elizabeth
Moss Galleries

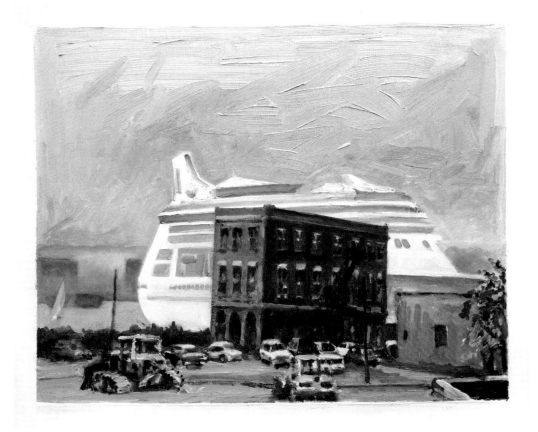

Since the late 1990s, a new vessel has been frequenting the Portland waterfront: the cruise ship. In Rush Brown's painting of the back of the Grand Trunk Office Building at the corner of India and Thames Streets, an ocean liner looms in hazy light, docked at the Maine State Pier. Brown's family lived on nearby Newbury Street from 2000 to 2013; he recalls a lot of construction and notes that "one can no longer gaze across this expanse because of new development." Artists, especially, take notice of these changes.

On a visit in 2006, Jill Hoy and her husband, Jon Imber, painted side by side on the docks, "the heartland of Portland's waterfront," drawn to this section of the city by their longtime attachment to their hometown, Stonington, and its vital fishing fleet. Hoy's *Knights of the Harbor* speaks to the encroachment of the tourism industry: the winged stern of a cruise ship is visible beyond the fish houses and fishing boats. The colors of the lobster buoys reminded her of "the banners and spirit of medieval knights, a lifestyle so valiant and respected."

Jill Hoy
Knights of the Harbor
Oil on canvas, 2006
14 by 24 inches
Courtesy Greenhut
Galleries

Jon Imber
Portland Dock
Oil on panel, 2006
20 by 30 inches
Courtesy Greenhut
Galleries

In his painting of the Custom House Wharf, Imber pays homage to what Hoy calls the "beautiful, honest backs of fishing docks." The painter, who succumbed to ALS in 2014, painted with abandon, channeling the energy of Abstract Expressionism. He lived to paint; the award-winning film portrait *Imber's Left Hand* highlights his determination.

Another frequently seen—and painted—vessel in and around Portland waters is the oil tanker, the modern-day avatar of the clipper ships of yore. David Campbell painted his *Sprague Terminal with Stormy Sky* from the harbor-side edge of the Forest City Cemetery in South Portland. "I haunted that place," he recounts, "always when low tide made for an intricate foreground pattern. Five bird species came and went while I worked, and of course they all went into the painting."

David Campbell
Sprague Terminal with Stormy Sky
Oil on panel,
2006–2007
Photo Jay York
Traub Collection

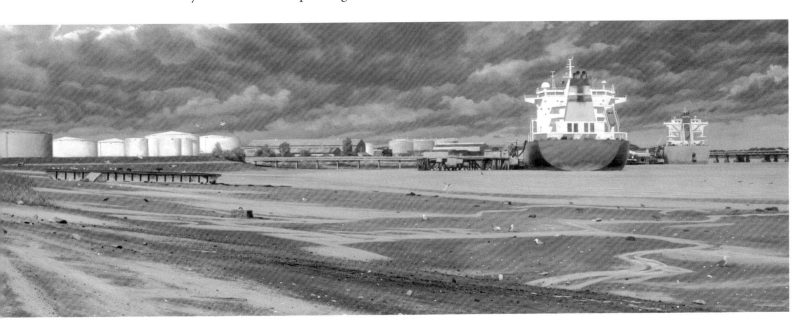

Philip Frey
Ruby Glow
Oil on linen, 2014
24 by 36 inches
Photo Ken Woisard
Collection of the
artist
Courtesy Courthouse
Gallery Fine Art

Sullivan-based painter Philip Frey has a lifelong connection to Portland, from birth to living in the city when he was in his twenties to having family and friends there. He came across the scene in *Ruby Glow* while wandering the city with camera and sketch-book at day's end, "when the sun's raking light illuminates in unexpected ways." Painting Portland, Frey says, "offers up a feast of color and compositional opportunities that pure landscape painting tends not to have."

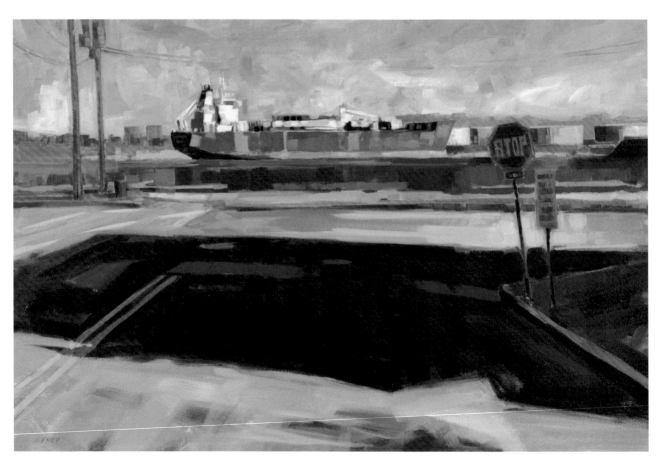

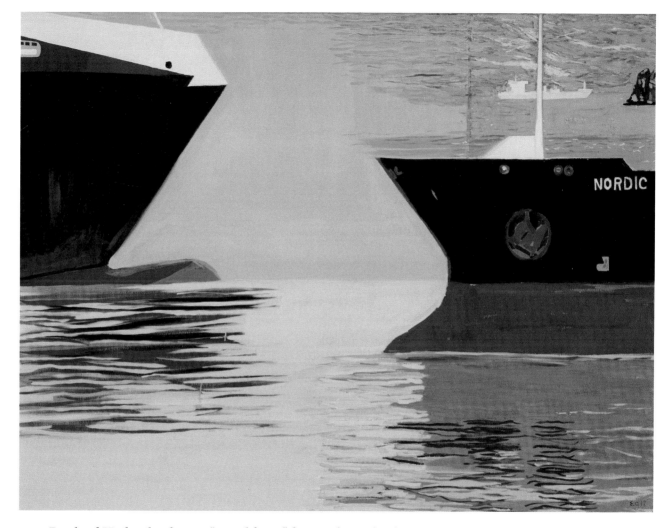

Ellen A. Gutekunst
Nordic Moon
Oil on linen, 2017
36 by 48 inches
Photo Jay York
Collection of the
artist

Portland Harbor has been a "visual focus" for South Portland painter Ellen Gutekunst ever since she had a studio in the Portland Company complex in 1987. Her series of tanker and container ship paintings was inspired by being up close to big vessels in a small boat. "The similarity of large hulls to color field paintings," she notes, "is a wonderful bonus to navigating Portland Harbor."

Sarah Knock
*Casco Bay Ferry
Reflection*
Oil on canvas, 2016
24 by 24 inches
Courtesy Greenhut
Galleries

David Clough
*Summer Fun—Port-
land Skyline*
Watercolor, 2010
12 by 18 inches
Courtesy David
Clough Designs

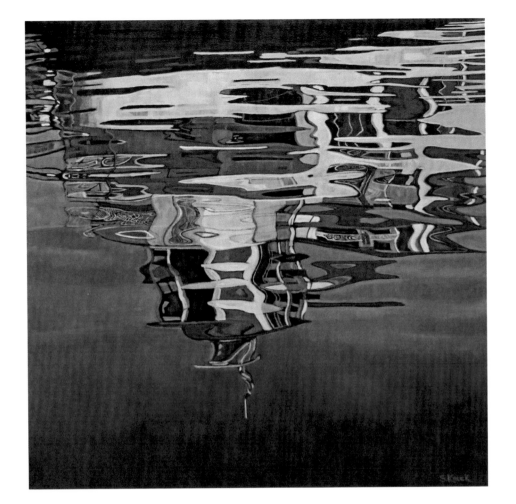

On a visit from her home in Freeport, Sarah Knock was walking down Commercial Street on a summer evening when she stopped by the Casco Bay Ferry Terminal to look at the ferries tied to the dock. The reflection of one of the boats in the water and its abstract beauty caught her eye. For someone who has consistently responded to the surface patterns of water using a palette of blues, greens, and neutrals, Knock had fun working with bright yellows and reds.

One of those bright yellow ferries crosses the water in David Clough's sunny watercolor of Portland Harbor. For a long time involved in advertising and the travel and hospitality industries (he was marketing director of Prince of Fundy Cruises), Clough took up painting with a passion in the late 1970s, eventually becoming a full-time watercolorist in 1986.

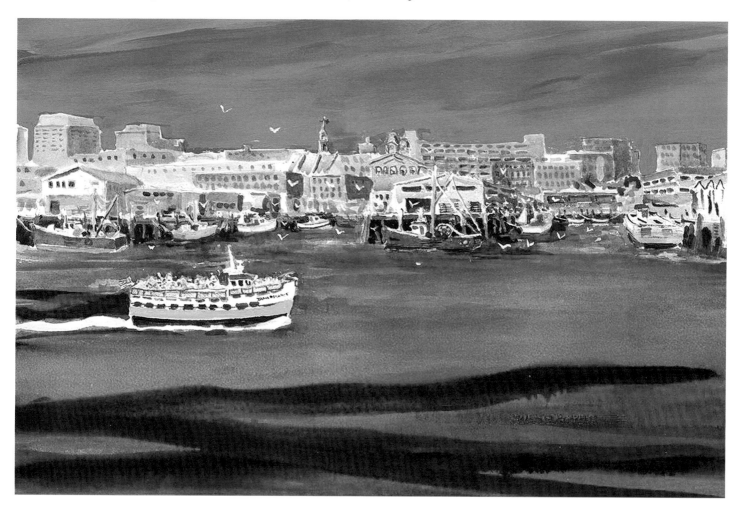

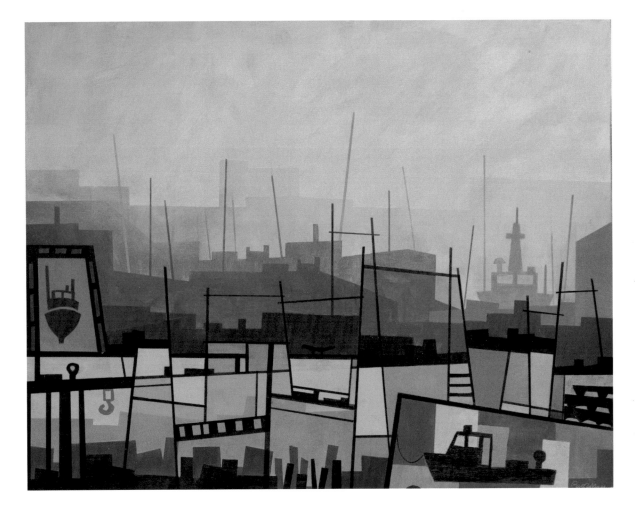

Chris Beneman
*The Working Water-
front #9*
Acrylic on panel, 2016
16 x 20 inches
Photo Jay York
Collection of Bruce
Hepler

Portland-area artist Chris Beneman considers the working waterfront to be "the soul of the city." Her fascination with the incredible variety of marine-related activity taking place on the docks along Commercial Street inspired a series of acrylic paintings that feature everything from lobster buoys to giant industrial cranes. A member of the Peregrine Press, a printmaking collaborative in Portland, Beneman brings a printmaker's eye to her compositions.

Another Peregrine Press artist, Alice Spencer, was inspired to paint her zoning map series by her visits to the Planning Office at City Hall when she served on the Portland Public Art Committee. "Zones were delineated either with straight lines or following natural geographic features like brooks or embankments," she notes, creating "an interplay of the organic and the geometric, which was aesthetically quite beautiful." She had begun to collect textiles from travels abroad and use their patterns. The local and the global came together in these patchwork quilt–like abstractions.

Alice Spencer
Portland Zoning Map #2
Acrylic on paper on board, 2006
10 by 8 inches
Courtesy Greenhut Galleries

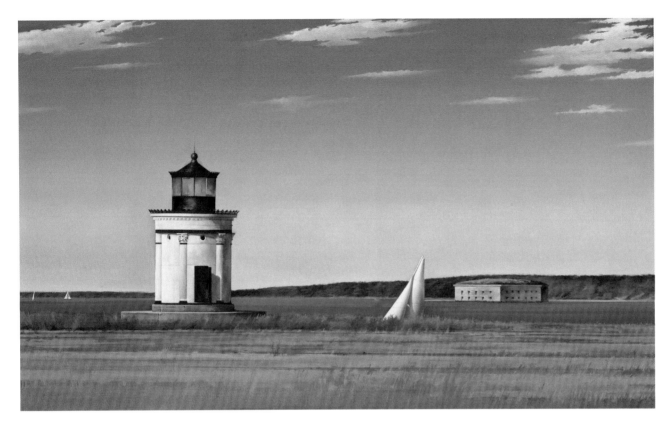

Joseph Nicoletti
Bug Light
Oil on canvas, 1987
22 by 30 inches
Collection of David
and Barbara Turitz

The coastal waters around Portland and the Casco Bay islands offer many engaging subjects. South Portland painter Joseph Nicoletti chose an up-close view of Bug Light when he was commissioned in 1987 to paint any landscape he desired in the Portland area. The artist was intrigued by this unusual structure, which was built in 1875 and features Corinthian columns, and its juxtaposition with Fort Gorges in the background. Nicoletti also felt challenged to tackle a clichéd image of the Maine coast. The sail of a boat in the middle distance is a direct homage to Edward Hopper.

Fort Gorges is also visible in Thomas Crotty's photorealist painting of the Spring Point Ledge Light Station, the sparkplug lighthouse sited at the end of a breakwater that juts into the main channel to Portland Harbor. The lighthouse was built in 1897 after

several shipping companies reported their vessels running aground on Spring Point Ledge. Crotty (1935–2015) also wore the gallery owner's hat, having run the Frost Gully Gallery in several locations in Portland over the course of nearly thirty years. Ardently opposed to the "art establishment" and the lack of attention paid to Maine's place in the history of American art, he championed the many Maine painters he represented.

Thomas Crotty
Dawn, Spring Point
Oil on panel, 1998
9 by 12 inches
Collection Richard and
Roberta Wright

On her daily walks on the shores of Peaks Island, painter Jamie Hogan encounters "compelling views of Portland and where the sky meets the water." She makes "small, urgent drawings as the colors change, chasing the memory of a cloud"—or a regatta passing in front of Fort Gorges.

Fort Preble, built in South Portland in 1806, was active as a protective fortification from the war of 1812 through World War II before being sold to the state of Maine and becoming the campus of Southern Maine Community College. In her painting of the

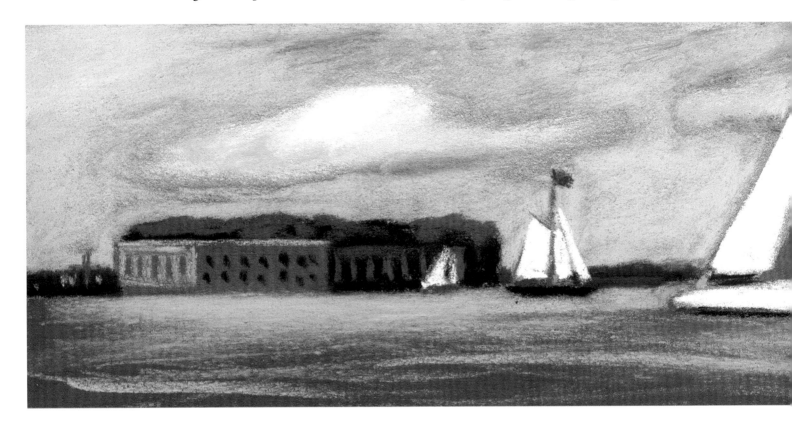

fort, Pat Hardy, who lives in North Berwick, provides a view of the ocean through a granite gun emplacement. Many of the Portland Show selections illustrated in this book, of which Hardy's painting is one, exhibit a freedom to explore and be inventive. Artists will tell you that every painting has a story, their anecdotes offering small but significant windows into their thought process.

Pat Hardy
Window to the Sea
Oil on canvas, ca. 1998
20 by 24 inches
Courtesy Greenhut Galleries
Private collection

Conley Harris
Mudflats, Casco Bay
Oil on canvas, no date
30 by 42 inches
Photo Bill Bentley
Collection Bank of
America

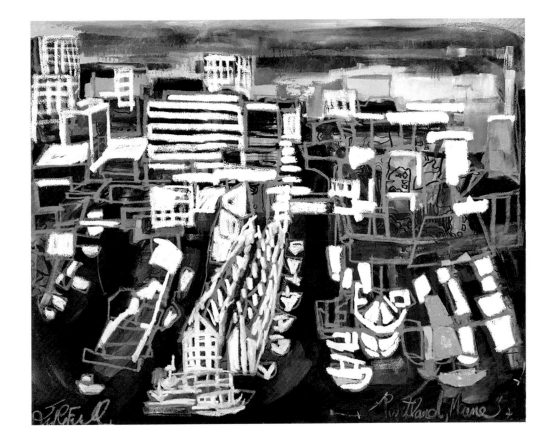

Erin McGee Ferrell
Aerial View Portland
Oil on canvas, 2017
48 by 60 inches
Courtesy the artist
and Portland Art
Gallery

Conley Harris devoted several oil paintings and watercolors to the Casco Bay mud-flats. Whether dark and wet or gleaming and slick, the "apron at Portland's edge," as he calls these tidal sands, have furnished him with a "hugely variable selection of pictorial images around which to construct my paintings." Falmouth-based artist Erin McGee Ferrell considers each of her paintings to be a kind of diary entry, representing a very specific time and place in her life. Her aerial image of the Portland waterfront is a part of a bird's-eye-view series of the city's bridges, piers, and infrastructure.

Tom Hall
Casco Bay Bridge
Mixed media, 2007
9 by 7 inches
Courtesy Greenhut
Galleries

A number of painters have been attracted to Portland's bridges. Tom Hall made a group of paintings of the Casco Bay Bridge in 2007, working from Conté crayon studies made on-site. He sought to capture some of the wonder that the bridge exhibits "in its bravado of form and movement" and "the grace with which it binds together the two Portlands." Completed in 1997, the bridge replaced the Million Dollar Bridge.

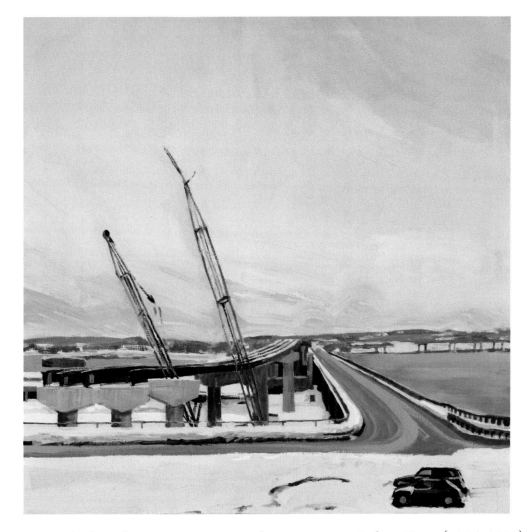

Robert Dyer
New Bridge, Winter
Oil on canvas, ca. 2011
36 by 36 inches
Photo Jay York
Courtesy Barridoff Galleries

In a fresh and energetic manner, plein-air painter Robert Dyer (1956–2013) depicted the Veteran's Memorial Bridge under construction in the winter of 2011 (it was completed in November 2012). Like the Casco Bay Bridge, it spans the Fore River between Portland and South Portland. Dyer made his living as an independent stonemason in the greater Portland area while painting around the city.

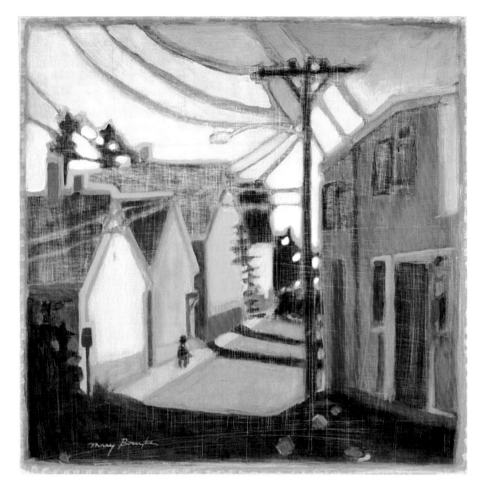

Mary Bourke
Living on Romasco
Acrylic on birch panel,
2014
20 by 20 inches
Photo Michael
Margolis
Collection of the
artist
Courtesy Greenhut
Galleries

Roy Germon
Toward Munjoy II
Acrylic on panel, 2016
14 by 14 inches
Courtesy Greenhut
Galleries

Choice of motif can be personal and autobiographical. Mary Bourke, who lives in Lincolnville, chose "quaint and quiet" Romasco Lane in the East End for one work because her son and his family lived there for a time with their "giant black dog, Daphne," who is pictured on the sunny sidewalk. In contrast, Portland painter Roy Germon chose Lincoln Park, "just inside the fence, near the corner of Congress and Pearl looking up Munjoy Hill," because he walks past this spot nearly every day and finds the elements aligned with his sense of place.

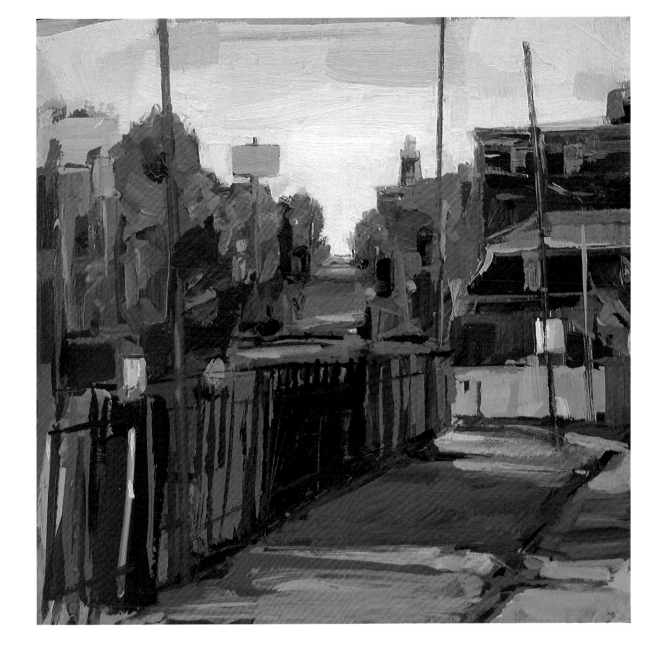

Nancy Wissemann-
Widrig
Tim's Place
Oil on canvas, 2004
18 by 24 inches
Courtesy Greenhut
Galleries

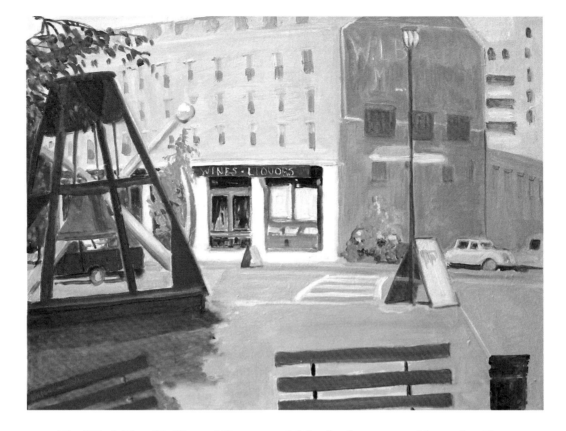

The "Tim's Place" in Nancy Wissemann-Widrig's oil painting of that title is Downeast Beverage across from the ferry terminal on Commercial Street; her son, Tim Wissemann, once owned it. Wissemann-Widrig, who summers in Cushing, recalls the humorous signs he used to place outside the store, including "Native Maine Ice" and "If It's Bad For You, We Have It."

Lindsay Hancock's *The View from Jenny's Window* is based on the prospect from a third-floor apartment of friends on Waterville Street just off the Eastern Promenade. "South Portland is in the distance," she notes, "and the soon-to-be-demolished Portland Yacht Services buildings are behind the homes." This painting joins the many that have become visual records of Portland's ever-changing landscape.

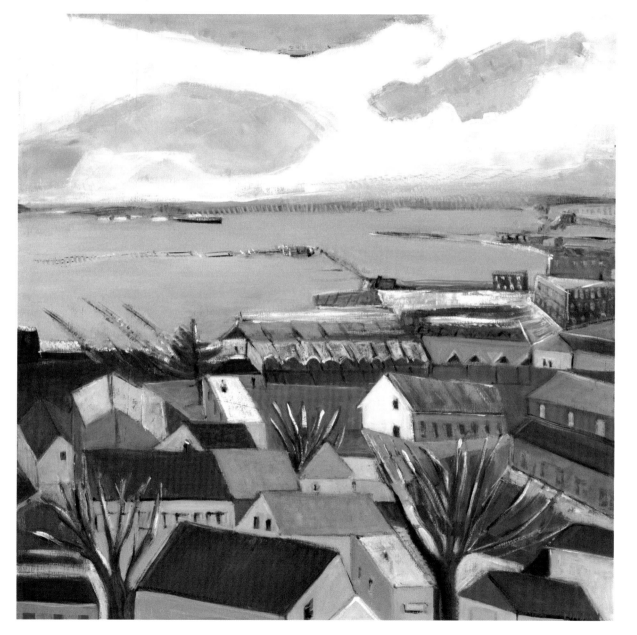

Lindsay Hancock
The View from Jenny's Window
Oil on panel, 2016
15½ by 15½ inches
Photo Jay York
Courtesy Greenhut
Galleries

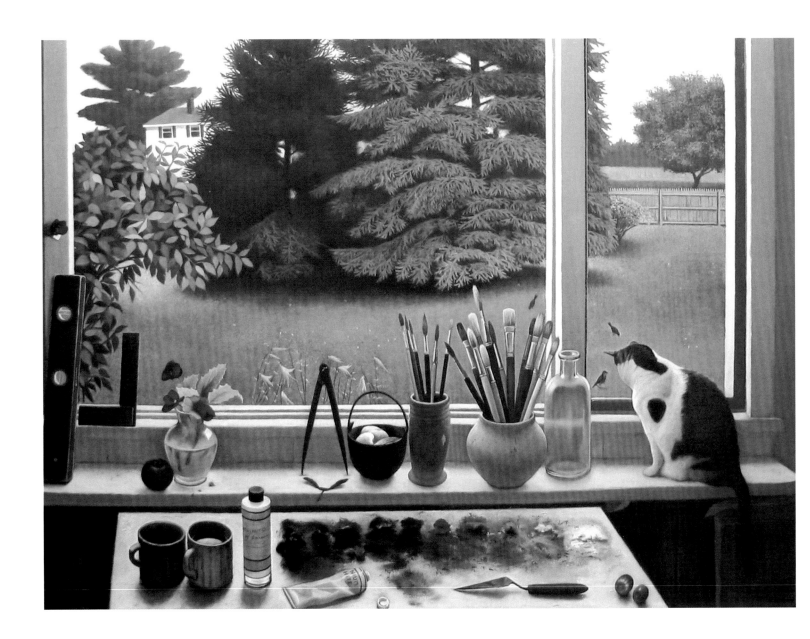

Thomas Nadeau
Brighton Avenue Backyard
Oil on canvas, 2006
25 by 34 inches
Courtesy Greenhut Galleries

Barbara Sullivan
Standard Baking Company
Shaped fresco, 2012
9 by 13 by 4 inches
Photo Jay York
Collection Sam and Jan Hayward

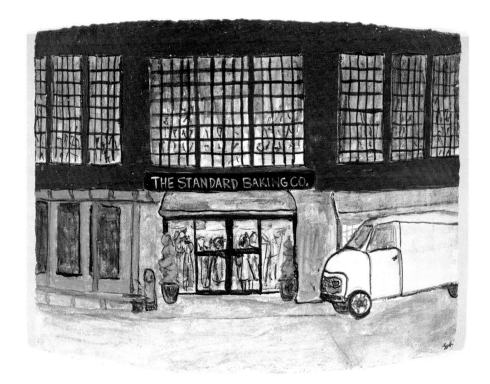

In a picture-window view of his backyard on Brighton Avenue, Thomas Nadeau includes a part of his studio in the foreground. Paintbrushes fill several vases and a palette displays his color choices, while a cat on the windowsill adds to the intimacy of the image. Nadeau studied with Alexander Bower (see p. 51), who promoted the idea that every young artist must rely on his or her own self-criticism.

Barbara Sullivan from Solon learned the ancient technique of fresco while working as a cook at the Skowhegan School of Painting and Sculpture in the late 1980s. In her shaped fresco *Standard Baking Company*, she presents the entrance to this renowned bakery on Commercial Street. Its flaky croissant helped gain Portland the title of "great bakery town" in *Bon Appétit* magazine in 2009.

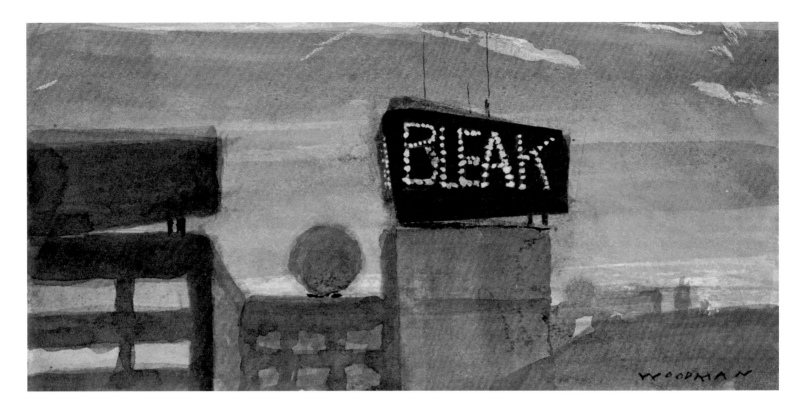

Bill Woodman
Time & Temperature
Watercolor, 2016
5½ by 11¼ inches
Photo Jay York
Collection of the
artist
Courtesy Gallery at
Somes Sound

Perched on the ocean and bordered by a tidal cove and river, Portland experiences its share of weather. In Bill Woodman's watercolor, the display screen at the top of the fourteen-story Time and Temperature Building says it all: "Bleak." The acclaimed *New Yorker* cartoonist, who was born in Bangor, can see the sign from his apartment in the Congress Square Plaza building.

For a time painter Alec Richardson lived on Morning Street, with the Eastern Prom serving as his backyard. He remembers how the fog would blow in and "clear the page like shaking an Etch-a-Sketch, only to clear out again to another grand view." The painter has expressed his gratitude for the city's commitment to the arts, which makes it "the perfect artistic incubator."

Alec Richardson
Morning Fog, Eastern Prom
Oil on canvas, 2002
24 by 20 inches
Photo Jay York
Collection George
Campbell

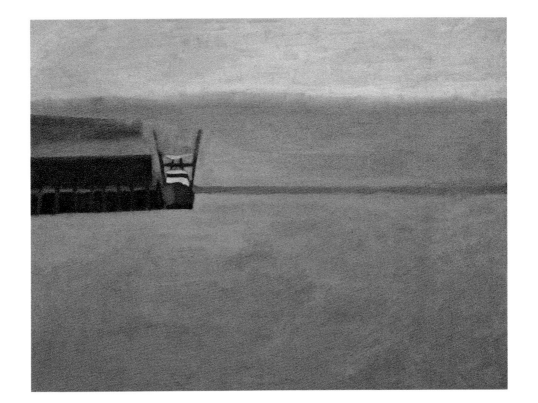

Margot Trout
*Boat at Dock, Fog,
Dusk*
Oil on canvas, 1987
22 by 28 inches
Collection Eva Hooker

Ben Aronson
*Silver Light on the
Waterfront, Portland*
Oil on panel, 2012
12 by 12 inches
Courtesy Greenhut
Galleries

While living in Portland from 1983 to 1988, painter Margot Trout taught at the Portland School of Art and painted landscapes "from direct observation." She sometimes conveyed her painting equipment to a particular site in a baby carriage; "it was undignified but effective," she recalls. She loved the evening light as well as the "extremely varied and dramatic" weather, which can be seen in her *Boat at Dock, Fog, Dusk*.

Boston-area painter Ben Aronson also looks for light in his landscapes. Invited to take part in the 2012 Portland Show, he set out on a bitterly cold day to find a point of view he liked. He chose a rooftop prospect looking down Commercial Street. "The challenge," Aronson recalls, "was to capture the icy restrained color, street activity, and glistening slashes of electric lines leading past the historic Custom House to St. Dominic Church . . . in the distant silvery haze."

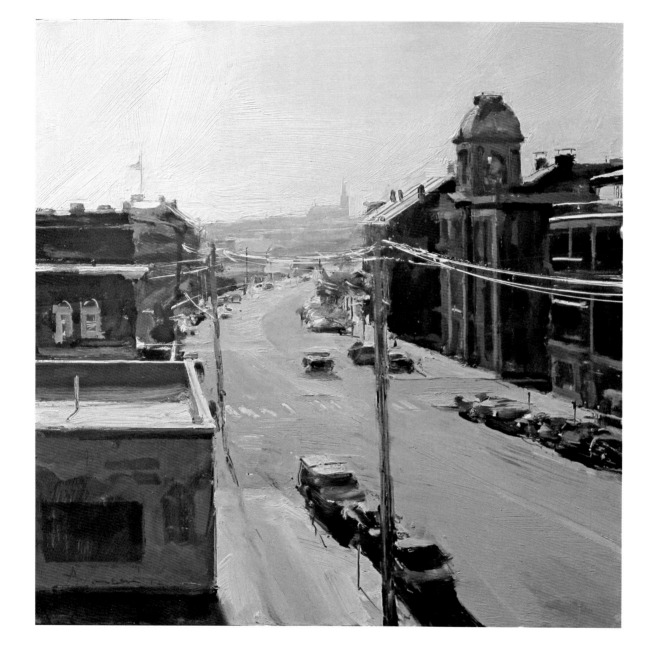

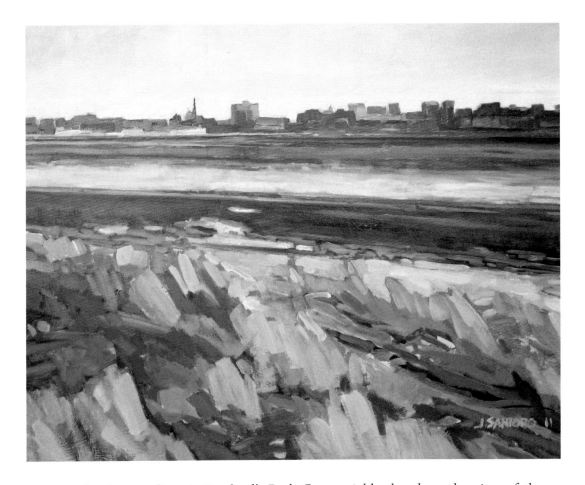

John Santoro lives in Portland's Back Cove neighborhood, so the view of the city skyline from Baxter Boulevard is a favorite. "I'm treated to the cove's ever-changing moods—evoked by tides, flora, and fauna," he writes. His midwinter view is full of light. By contrast, James Mullen's painting of Back Cove captures the scene at dusk. Mullen, an art professor at Bowdoin College, imbues his twilit view with film noir–like mystery by way of a lone car traversing the boulevard in the foreground.

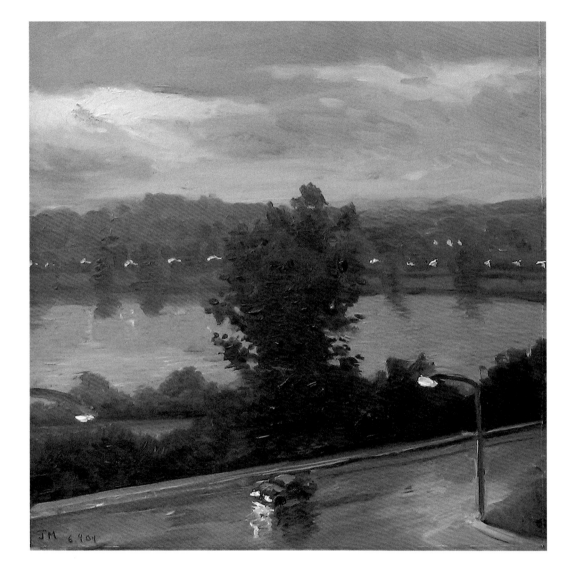

James Mullen
Back Cove
Oil on Plexiglas, 2008
17 by 13 inches
Private collection

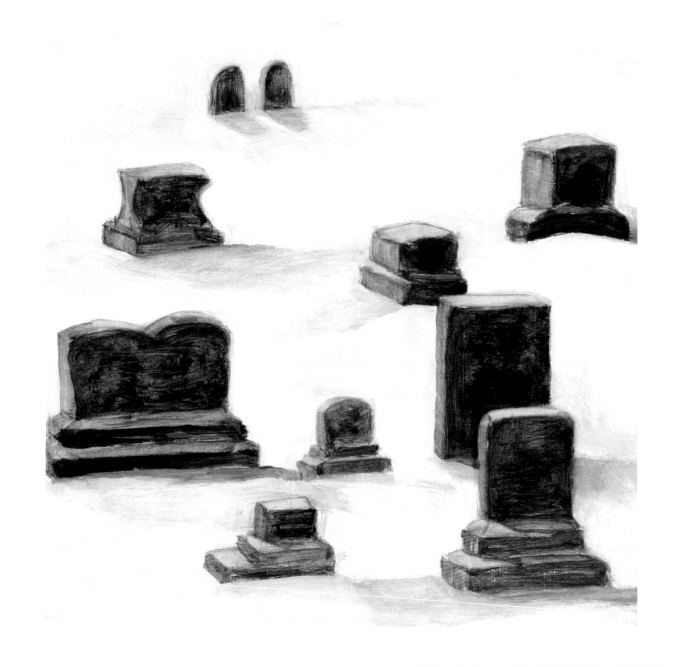

Jessica Gandolf
Evergreen Cemetery
Oil on panel, 2010
8 by 8 inches
Photo Jay York
Collection of the
artist
Courtesy Greenhut
Galleries

Richard Jacobs
*Chapel in Evergreen
Cemetery*
Watercolor, 2017
14 by 10 inches
Photo Jay York

Portland boasts a good deal of green space, places where residents and visitors alike can find respite from the urban buzz. Jessica Gandolf believes Evergreen Cemetery is the best place for a walk in the city. She loves how the headstones in this 239-acre resting place (the largest in Maine) relate to each other and echo "the true companionship" the Portland painter feels walking there with friends. They also offer "a measure of solace and beauty in their wobbly geometry," she says. Gandolf's all-time favorite epitaph is "She Hath Done What She Could."

Richard Jacobs calls Evergreen Cemetery one of the "few unchanging historical gems of Portland." In his watercolor of Wilde Memorial Chapel, an important visual landmark in Deering Center, the Gothic-style structure is a study in grays under an overcast winter sky.

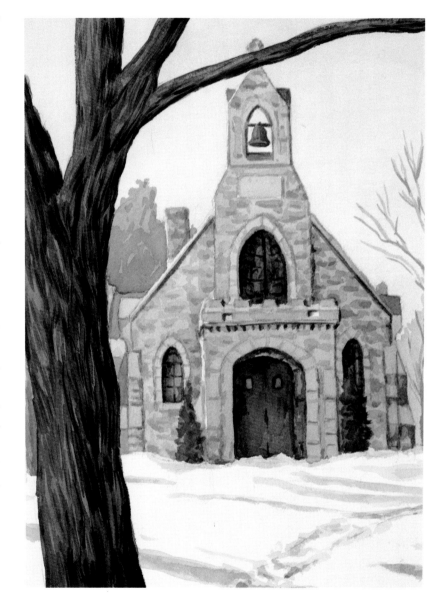

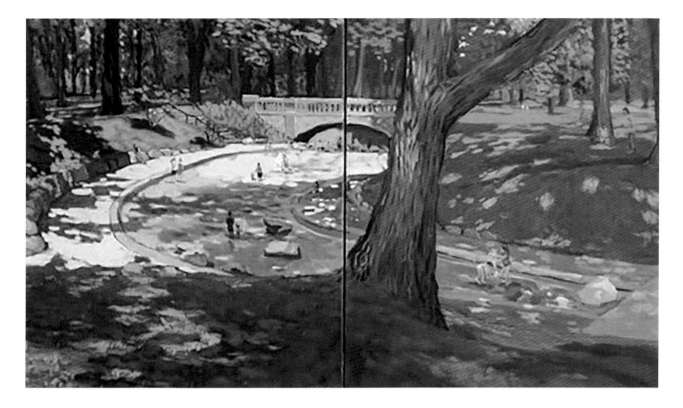

Finn Teach
Return to Innocence
Oil on canvas, 2010
Diptych, 24 by 30
inches each
Private collection

Born in Bar Harbor, Finn Teach has made a home in Portland. One of his favorite places is the ravine in Deering Oaks Park; the wading pool and splash pad are a tribute to Kay Wagenknecht-Harte (1951–1997), urban designer for Portland. In a diptych painted on-site, Teach depicts the arched footbridge and children playing in the sun-dappled water. The fifty-five-acre public park, which is listed on the National Register of Historic Places and is supported by Friends of Deering Oaks, is the setting for the Portland Farmers' Market—and was the inspiration for part of Longfellow's poem "My Lost Youth":

And Deering's Woods are fresh and fair,
And with joy that is almost pain,
My heart goes back to wander there . . .

Several sports teams make their home in the city, most notably, the Portland Sea Dogs, a minor league franchise of the Boston Red Sox that plays at Hadlock Field. Nancy Morgan Barnes from Searsport enjoyed the challenge of trying to depict "an established tradition like American baseball." In 2014, Portland was named the best minor league baseball town in the United States and the Sea Dogs were Baseball America's Team of the Year.

Baseball isn't new to Portland. Going back more than a century, a hand-painted broadside from 1894 announces a matchup between the city's "Murphy Balsam" baseball team and the Poland Spring Fellows. The artist included a man in cap relaxing against a tree with a broken pitcher on the ground in front of him—a reference to the Poland Spring team's loss of one of its hurlers.

Nancy Morgan Barnes
Portland Sea Dogs
Oil on board, 2013
16 by 23 inches
Courtesy Greenhut Galleries

Ralph Plaisted
(attributed)
Baseball Challenge
Gouache on paper, 1894
23½ by 16½ inches
Collections of Maine Historical Society

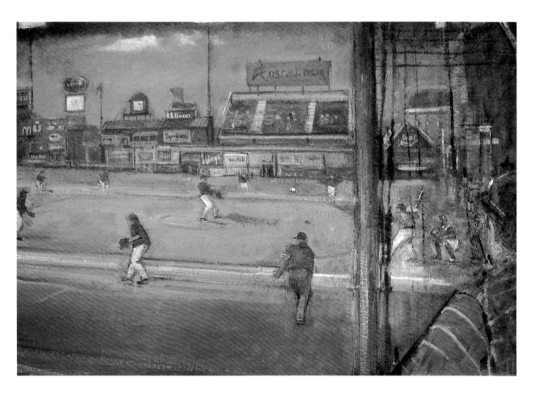

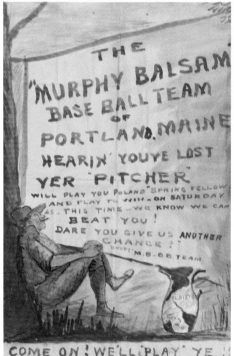

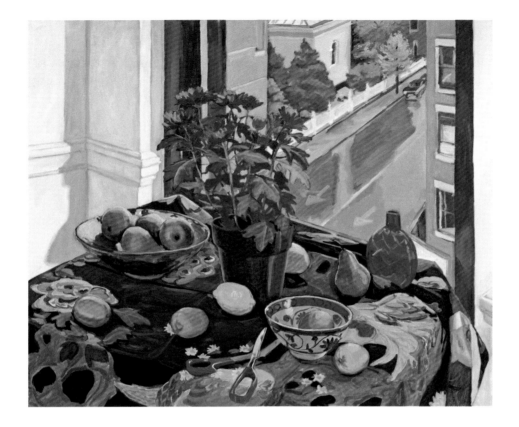

Debra Yoo
Portland Still Life
Oil on canvas, 2001
33 by 44 inches
Photo Jay York

Portland can serve as the backdrop—and subject—for a still life. Debra Yoo painted her arrangement of fruit, flowers, vase, and scissors in her first studio in the State Theater building, which overlooked Congress and High Streets. She liked the contrast of parallel lines created by the interior and exterior architectural elements set against the "pyramid of rounded objects and patterns on the table."

When painter Alison Goodwin was a child growing up in Portland, her family attended Sacred Heart Church on the corner of Mellen and Sherman Streets. She remembers walking over from her neighborhood off Brighton Avenue and imagining people gazing down from the windows above—like the view from on high of the church's steeples in her still life. Goodwin notes that in recent decades the church has become one of the

most vibrant and diverse places of worship in Portland. "The Hispanic and African communities have found a home at Sacred Heart, and their music, passion, and spirit fill the expansive building," says Goodwin.

Alison Goodwin
Sacred Heart Church
Acrylic and oil pastel
on paper, 2010
23½ by 23½ inches
Private collection
Courtesy Greenhut
Galleries

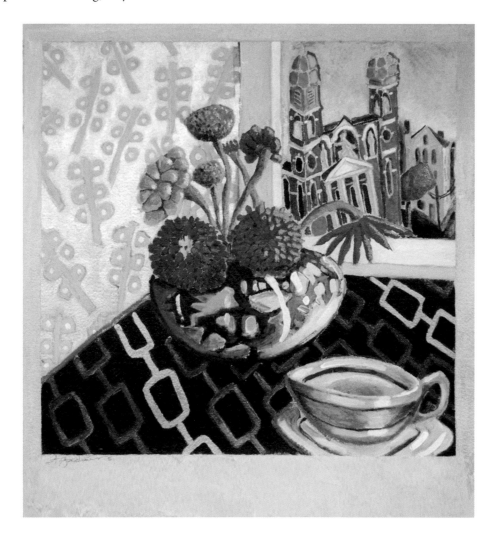

Frederick Lynch (1936–2016) was one of Maine's foremost abstract painters. He moved to Maine from Massachusetts in the 1970s and lived in Saco from 1996 until his death. For the 2006 Portland Show he offered an exquisite rendering of a stained glass rose window from St. Lawrence Church on Munjoy Hill. First built in 1897, the church's Parish House is now home to the St. Lawrence Arts and Community Center. Lynch once said, "My intention is beauty; my goals, pleasure and joy."

A kind of trompe l'oeil effect characterizes still lifes by Joseph Nicoletti and Janet Conlon Manyan. In search of something different for the 2002 Portland Show, Nicoletti contacted an antique postcard collector and borrowed several vintage images. His challenge, he writes, was to compose the postcards of Portland and the still-life objects "such that there was a certain dialogue between them." Manyan, who lives in Saco, brings a similar classicism to her still life of bottles and crows. She blends inside and outside by including a painting of Portland's City Hall and the spire of the Cathedral of the Immaculate Conception.

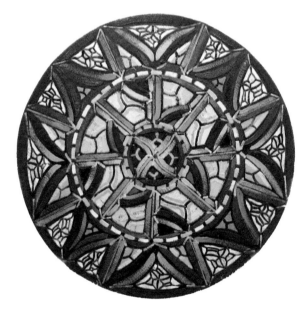

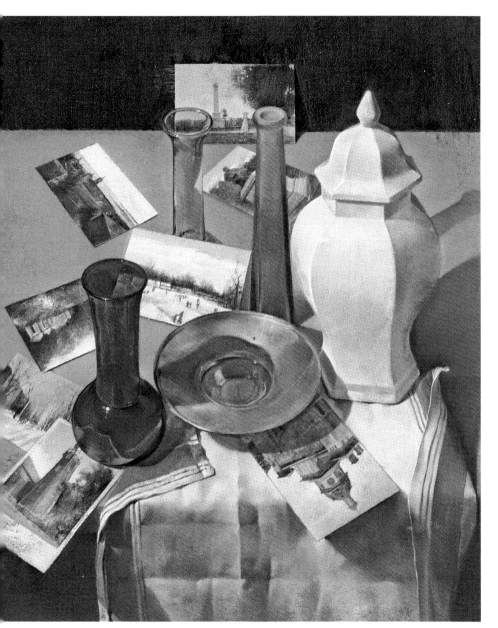

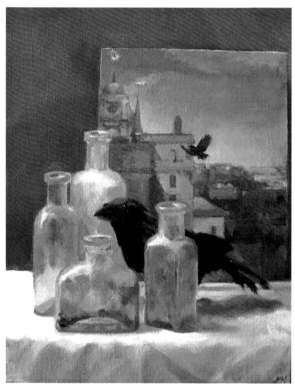

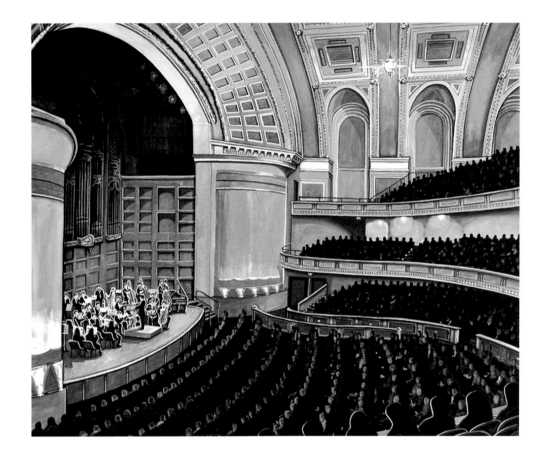

Robert Cohen
Orchestra Night at the Merrill
Watercolor, 1997
24 by 30 inches
Collection City of Portland

Robert Cohen
Sliding at Payson Park
Watercolor, 2004
18 by 24 inches
Courtesy RN Cohen Studio-Gallery

Robert Cohen owned and operated galleries on Congress Street and Exchange Street before semi-retiring to a life of painting (his studio/gallery today is at Congress Square in the State Street Building). He has painted a variety of well-known Portland scenes and venues, including Merrill Auditorium, the performance space built in 1911 that is home to the Portland Symphony Orchestra and features the famous Hermann Kotzschmar Memorial Organ. Cohen's painting of families sledding in Edward Payson Park on Ocean Avenue is a quintessential winter scene.

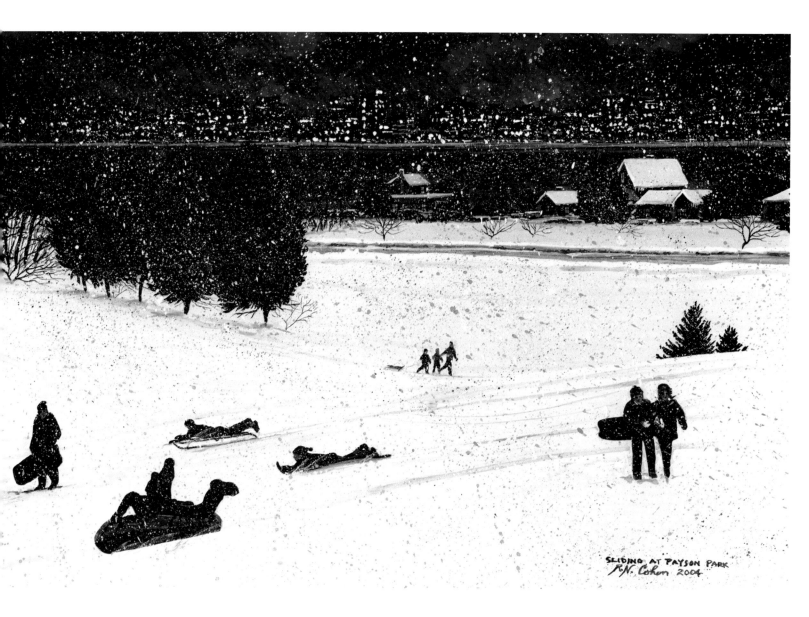

SLIDING AT PAYSON PARK
R.N. Cohen 2004

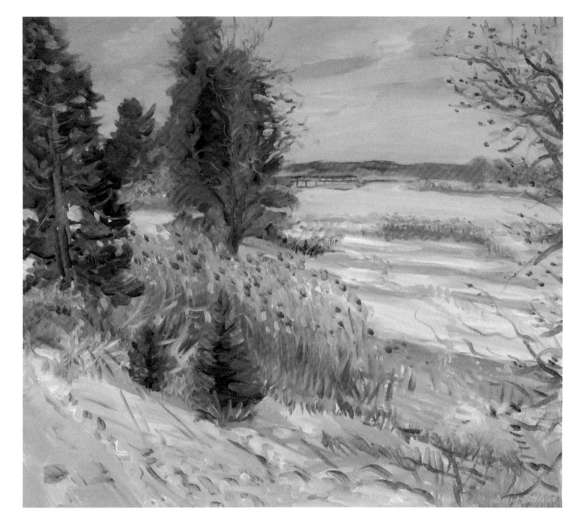

David Little
Winter's Promise (after Willard Metcalf)
Oil on canvas, 2005
22 by 24 inches
Collection Ted and Joan Koffman

David Little
March Blizzard—Deering Center
Oil on canvas, 2001
24 by 24 inches
Collection of the artist

In addition to well-known city landmarks and views, artists have found motifs in more removed spots like Gilsland Farm, Kettle Cove, Scarborough Beach, and Stroudwater. David Little's view of the Presumpscot River from Maine Audubon's Gilsland Farm in Falmouth, painted on snowshoes, exemplifies his eye for representing winter, which is also evidenced in a view from his studio window on Brentwood Street during a spring blizzard.

Little's long-time painting companion Douglas Howe is an equally devoted plein-air painter, scouting shorelines in search of a suitable subject. For his view from Kettle Cove at Crescent Beach in Cape Elizabeth, he uses the bluff and bushes to frame part of Richmond Island on the left and Ram Island Farm on the right.

Douglas Howe
The Bluff, Kettle Cove
Oil on canvas, 1987
14 by 18 inches
Private collection

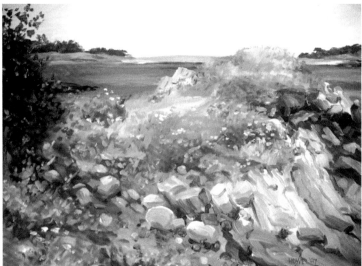

John Swan
*Summer Time—
Scarborough Beach*
Oil on canvas, 2014
18 by 24 inches
Collection of the
artist

Vivien Russe
Scarborough Beach II
Acrylic on panel, 2011
15 by 15 inches
Photo Jay York
Collection of the
artist

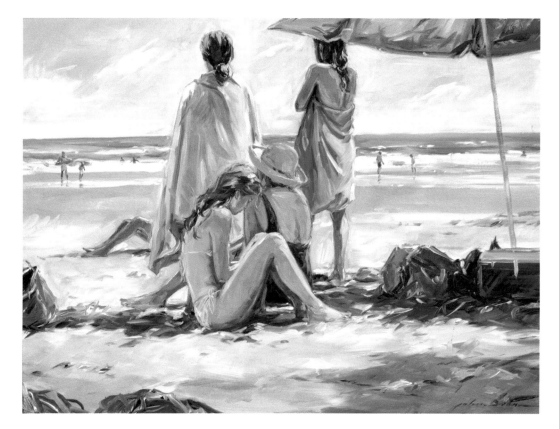

Painter John Swan lives in the former home and studio of painter Walter Griffin (see p. 38) in the historic Stroudwater district. His *Summer Time—Scarborough Beach* is a sun-filled portrait of his family enjoying a visit to the ocean. The artist's portraits and landscapes are inspired by Winslow Homer and John Singer Sargent.

A different take on that same stretch of seaside can be found in Portland painter Vivien Russe's *Scarborough Beach II,* which juxtaposes a view of the sea with a pillow. The artist considers the two-part piece an exploration of the relationship of movement to stasis—and an homage to the mobility-challenged patients she cares for as a nurse.

Marguerite Robichaux
Stroudwater
Oil on linen, 2005
44 by 24 inches
Photo Dennis Griggs
Courtesy Greenhut
Galleries

Michael Waterman
The Leopard
Oil on canvas, 1994
40 by 60 inches
Photo Jay York
Collection Andres A.
Verzosa

Being a painter of primarily rural, woodland, or agricultural landscapes, Marguerite Robichaux, who lives in Stratton, in western Maine, felt challenged to find a subject in Portland "appropriate to her oeuvre" when she was invited to be in the 2006 Portland Show. She and her buddy, writer Elizabeth Peavey, scouted out possibilities, including the Eastern and Western Proms, Deering Oaks Park, and Evergreen Cemetery, until they "stumbled upon the beautiful little falls over the dam at Stroudwater." It was, she recalls, "perfect."

The city also invites fantasy. Portland-born painter Michael Waterman frequently turns to allegory in his surreal images. *The Leopard*, for example, offers a warmly glowing vision of the city, from East End to West End, set on the undulating back of a jungle cat. Critic Britta Konau once called Waterman's paintings of Portland "poems of love and passion dedicated to that home we all carry around inside of us, whatever specific form it may take for each of us."

Richard Wilson
*Two Lights Eastern
Prom*
Oil on gessoed board,
2015
13 by 6 inches
Photo Jay York
Collection David and
Linda Pence

Painter and printmaker Richard Wilson worked from photographs of the Fourth of July fireworks display over Casco Bay to create his fantastical *Two Lights Eastern Prom*. "The apocalyptic look of the fireworks, with the light coming through the trees with long shadows," he recounts, "balanced the benign little snack stand and the people milling around it."

Katherine Bradford, who divides her year between Brunswick, Maine, and Brooklyn, New York, considers the nighttime view of Portland, with its lights reflected in the water, a "sensational sight." She found a vibrantly colored photograph of the scene and affixed it to the center of a large work on paper, using gouache to fill in the surrounding space with "matching colored sea and appropriate buildings." To top off the aura of a fantastical, heavenly, and romantic city, she added collaged images of flying naked women, their arms outstretched.

Writing in 2002 about what attracts artists to Portland, critic Edgar Allen Beem observed that it is "the lay of the land for sure, but . . . also the built environment, the way the present appropriates the past, the way we live our lives here and the way our predecessors lived theirs." Portland is just a small city by the sea, he noted, "but it contains multitudes."

Paintings of Portland offers a first visual survey of this city of multiple motifs, moods, and memories. May this book serve as an invitation

to discover a vibrant art scene, past and present; to understand more fully how artists heighten our appreciation, by way of paint and report, of this special place with all its changes; and to recognize how fortunate we are to have such creative individuals in our midst. As audience and authors alike, we join these artists in celebration of this fascinating city by the sea.

Katherine Bradford
Women over Portland
Gouache and collage
on paper, 2006
22 by 30 inches
Collection Anne Zill

Bibliography

Barney, Grace L., and Katherine F. Woodman. *A Century of Portland Painters 1820–1920*. Exhibition catalogue. Portland, ME: Portland Museum of Art, 1970.

Barry, William David. *Artists at Portland, Maine 1784–1835*. Portland, ME: Portland Museum of Art, 1976.

Barry, William David. "Maine & the Arts." In *Maine: The Pine Tree State from Prehistory to the Present*, eds. Richard Judd, Edwin Churchill, and Joel Eastman. Orono: University of Maine Press, 1995.

Barry, William David, and Patricia McGraw Anderson. *Deering: A Social and Architectural History*. Portland, ME: Greater Portland Landmarks, 2010.

Conforti, Joseph A., ed. *Creating Portland: History and Place in Northern New England*. Durham: University of New Hampshire Press, 2005.

Dibner, Martin, ed. *Portland*. Portland, ME: Greater Portland Landmarks, 1972.

Maine Memory Network, a project of the Maine Historical Society. www.mainememory.net.

Neal, John. *Portland Illustrated*. Portland, ME: W. S. Jones, 1874.

Nicoll, Jessica. *Charles Codman: The Landscape of Art and Culture in Nineteenth-Century Maine*. Portland, ME: Portland Museum of Art, 2002.

Routhier, Jessica Skwire. *Vividly True to Nature: Harrison Bird Brown 1831–1915*. Portland, ME: Portland Museum of Art, 2007.

Shettleworth Jr., Earle G. *Charles Frederick Kimball 1831–1903: Painting Portland's Legacy*. Portland, ME: Portland Museum of Art, 2003.

Shettleworth Jr., Earle G. *A Painter's Progress: The Life, Work, and Travels of Harrison B. Brown of Portland, Maine*. Portland, ME: Phoenix Press, 2005.

Shettleworth Jr., Earle G. *The Paintings of John Calvin Stevens*. Portland, ME: Greater Portland Landmarks/University of New England Art Gallery, 2015.